The Tao of Sketching

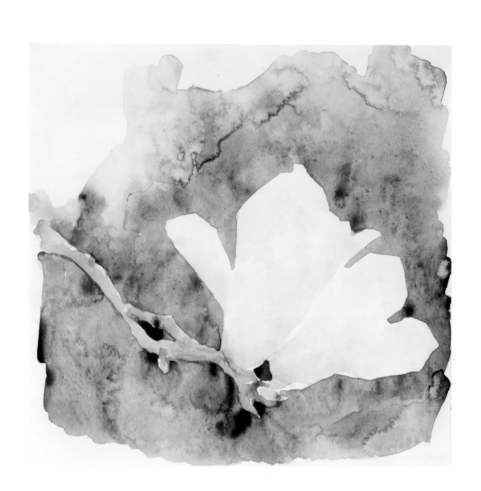

The **Tao** of Sketching

The complete guide to Chinese sketching techniques

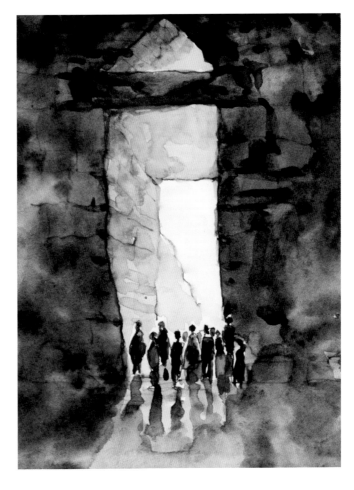

Qu Lei Lei

CICO BOOKS
LONDON NEW YORK

First published in 2006 by Cico Books
an imprint of Ryland, Peters & Small Ltd
20-21 Jockey's Fields
London WC1R 4BW
Copyright © Cico Books Ltd 2006

Text copyright © Qu Lei Lei 2006
Photographs © Cico Books 2006

10 9 8 7 6 5 4 3 2 1

A CIP catalogue record for this book is available
from the British Library

ISBN-10: 1-904991-29-7
ISBN-13: 978-1-9049-9129-8

Printed in China

Editor: Robin Gurdon
Designer: Ian Midson
Photographer: Geoff Dann

CONTENTS

INTRODUCTION

中外得師心造源化

"On the outside we learn from nature, but on the inside we learn from our soul"

Yao Zui (555–603 C.E.)

This is the most important tradition of Chinese art as it describes both man's relationship with nature and how he can show that he has achieved a full and true understanding of nature through his art.

The philosophy behind traditional Chinese art is not, as many people say, "paper copy paper." In fact the true Chinese masters have always been concerned with learning directly from nature.

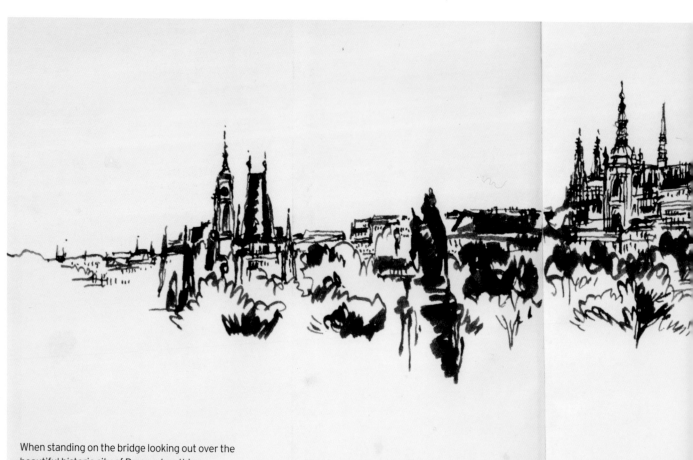

When standing on the bridge looking out over the beautiful historic city of Prague, two things touched my heart–the statue and the skyline–so these were the details I caught in the sketch.

天 人
法 法
道 地
道 地
法 法
自 天
然

"Man is ruled by the Earth, and Earth is ruled by Heaven, and Heaven is ruled by the *Tao*, and the *Tao* is ruled by nature"

Lao Tzu (604–531 B.C.E.)

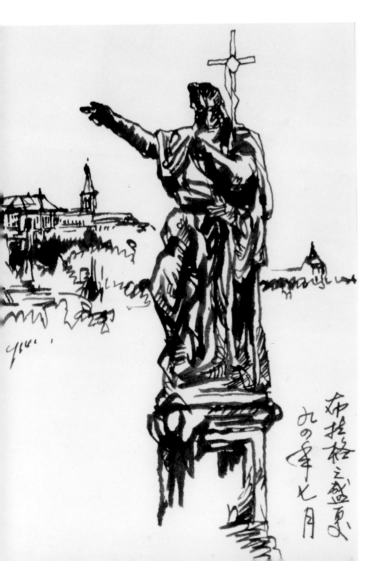

In this phrase, Lao Tzu, the creator of the Taoist philosophy, was affirming his central idea, that the highest ruler in the universe —and the pinnacle of truth and beauty—is nature itself.

The art of sketching is the most direct way in which we can learn from nature, from the sky to Earth, mountain to river, humans to animals, and birds to plants. A basic knowledge of drawing techniques to capture nature's forms, the ability to observe with the eyes, and to express ourselves by the hand are necessary, but these are not enough. To master the art, as well as our eyes and hands, we also need to use our brains and hearts to find a deeper understanding and feeling of nature. The painter needs to see the object from its surface through to its essence. Objects in nature are emotionless but through the artist's understanding he can put feeling and culture into them, filling those objects and shapes with emotion.

In other words, through the drawing of the natural world, the painter can imprint his own personality and cultivation.

為天下式 知其白守其黑

Lao Zi (5th–6th century B.C.E)

"We must understand the white, and then play with the black: that is the system of the universe."

In the Tang Dynasty Fu Zai said, "The painting is not paint, it is the *Tao*." This means that when we paint we are painting not only a picture but also a philosophy. But what is this philosophy? An ancient Chinese master created the tai chi pattern to describe the central factors of the *Tao*.

This simple pencil sketch succeeds in combining the qualities of stillness and movement, so bringing the sound of the music to life. The energetic movement of the musician's arm and body is constantly revolving around the stillness of the cello.

From this pattern, we can see:

1 Everything in the universe is combined with its opposite, a combination of black and white called yin and yang.

2 Yin and yang remain the balance of endless movement.

3 Yin and yang both include an element of the opposite side—there is white in black, and black in white.

4 Yin and yang are ever-changing and transferring to each other all the time.

Creating the abstract

When we build a house using wood, stone, and brick tiles we make walls and a roof structure that can be seen and touched. But the purpose of construction is to create the space inside, which cannot be seen or touched.

When we make a cup, a plate, a bowl, or a bottle, for example, we use different materials and methods, but all make containers with a hollow space. The end purpose is not the physical object made by the materials, but the abstract part that we cannot see—the hollow space that has been created to hold or carry something else.

Painting to describe form

In the same way, through our brushes and the black lines and dots of ink, when we paint mountains, trees, and villages, we are actually describing formless things—the sky, water, and the chi, or energy—within those objects. When we are doing a sketch, when we observe nature, we should consider the relationship between yin and yang.

Yin and yang not only express the contrast between black and white; these two forces include the contrasting elements of heaviness and lightness, solidity and emptiness, stillness and movement, the fast and the slow, cold and warm, bright and dark. When we capture these elements in our work, we are able to master the objects we are going to paint and can then sketch at a higher level.

As expressed in Chinese philosophy, respecting the principles of yin and yang is the key to understanding the world.

The dark interior space of this Turkish tomb is created by contrasting it with the very focused bright light streaming in from outside. In this small picture the figures were also contrasted with the sunlight. I could only show how bright the sun was by darkening the silhouetted figures.

This girl is sitting in the woods with bright sun shining through the leaves, captured by the sharp blackness of the dots.

"Express the Spirit through what you paint"

Gu Kai Zhi (345–406)

Gu Kai Zhi advanced the theory that he could achieve true art only when painting if he expressed the object's spirit. This means that when we draw a sketch or paint a picture it should not simply be a record of the object—a camera achieves this more successfully. What we have to do is catch and express the object's spirit. In both the East and the West, before photography was invented, the Old Masters could record life, research a concept, and develop their ideas only through sketching.

Expressing the spirit

In order to express the spirit, we must have a breadth of practical techniques: We must have the ability to draw the object with the correct materials in hand, and learn to use properly the time we have. We must learn many different skills—but this is only the start.

In the fifth century the great philosopher Xie He studied the works of many great artists as well as his fellow philosophers, and distilled their thoughts into what he described as the six standards for painting. Even today this represents a complete system for Chinese art.

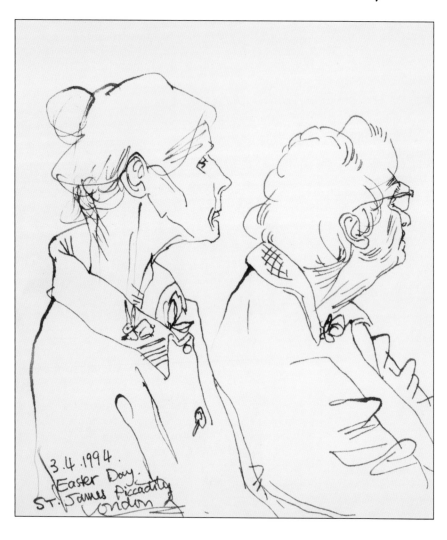

3.4.1994.
Easter Day.
St. James Piccadilly
London

Two women in church

傳 經 隨 應 骨 氣
移 營 頻 物 法 韻
模 位 賦 象 用 生
寫 置 彩 形 筆 動

The six standards for painting

1 *Qi yun sheng dong*
"A good painting requires life (*chi*), rhythm, and spirit."

2 *Gu fa yong bi*
"The brush must always be worked in a controlled manner, in a way derived directly from the art of calligraphy."

3 *Ying wu qiang xing*
"Use the previous two rules to allow you to form the shape of any structure you like with the paint according to reality."

4 *Sui lei fu cai*
"Recreate the color according to the natural world."

5 *Jing ying wei zhi*
"Arrange the composition."

The six standards of painting that have been the basis of Chinese art for well over 1,000 years were first described by the great philosopher Xie He in the fifth century.

6 *Chuan yi mo xie*
This phrase has two very different meanings, but both are relevant to sketching. The first is:
"Learn from the old masterpieces."

The second is:
"Use your imagination to modify the scene."

These six points provide a clear pattern through which it is possible to paint a proper picture. To make a successful painting, practical techniques are also necessary, and in this book we are going to give you the basis from which you can discover the art of Chinese sketching, and give you the recommendations and suggestions to you need to succeed.

格高逸筆墨精妙

"The more learned the man, the better his brush and ink work."

Emperor Xiao Yi-Liang Yuan Di (508–554)

This quotation explains the relationship between the artist and his painting. We often say that an artist's personality can be judged from his painting, so a painter with an honorable personality and deep wisdom will naturally paint a picture of high quality.

Many sayings from traditional Chinese art theory follow this: If you want to improve the quality of your painting you must first improve the quality of yourself.

心畫

"The track of the heart."

The brush or pen is the extension of the heart: We see everything in the world through the eye, feel it through the heart, and think about it through the brain, All of these are combined and transferred to the paper through our hand and brush. Therefore, every stroke of the brush is actually an extension of the soul.

When we draw natural objects we express our cultivation, our taste, and our personality. The style of the painting shows the style of the person.

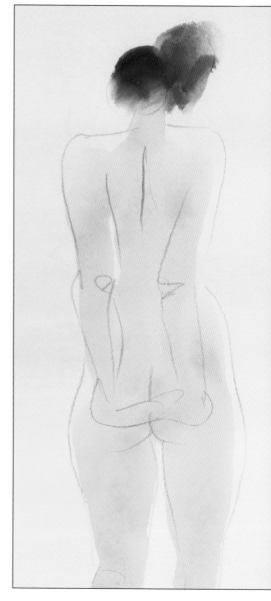

The artist's soul can be shown even in the few strokes of a simple pencil and color wash figure drawing taken from life.

依於仁 志於道
遊於藝 據於德

"My ambition is to understand the *Tao*. Only if I follow the rules of morality, founded on kindness, can I play in art"

Confucius (551–479 B.C.)

Confucius saw art as a journey, a game, an entertainment with man using it to move through life, improving each individual's self-cultivation. On the journey we are following the *Tao* and beauty of nature. The rules that we follow should be moral.

All these things are based on the central idea of Confucianism: kindliness, compassion, and love. Only when we strive to live to these ethics can we hope that we will make good attempts at art. Of the many diseases in art, the worst is vulgarity.

澄懷觀道

"Open the chest to clear the mind to realize the *Tao*"

Zong Bing (375–443)

During his life Zong Bing enjoyed traveling through the natural world of mountains and rivers. When he was old and ill and could not continue his journeys, he painted the most beautiful views he had seen during his life. He lay in the bed continuing his journey, and he called it "lying down traveling."

He also played musical instruments to resemble the echoes between the mountains. He saw art as a philosophical label through which to realize and improve both his mind and quality of life. The style of his life and the style of his art match.

冥心用舍 幸從所好

"If you do your best and feel lucky you can enjoy art."

Yao Zui (555–603)

Yao Zui studied the art of painting and the great Chinese masters that came before him and came to the conclusion that, however noble, cultured, or learned, it is impossible to paint well without spending a huge amount of time practicing the necessary skills. When he described Zhang Seng Yao, one of the greatest artists in China's history, he mentioned that he never got tired, day or night. He was always ready to paint and whenever he did paint, the brush never left his hand. This is the way in which he became a great artist.

Birds return to roost as dusk falls. To sketch well does not always necessitate the use of many materials and complex composition. A simple form can say a great deal about a scene.

Seen from a train, the country is bathed in sunshine as the clouds break after a rain storm. Even when using a single pen and no color the freshness is clear.

去诺丁汉。去回我们盈罗宾汉的剑。

立萬象於胸懷 "Build everything you see in the natural world in your heart"

Yao Zui (555–603)

The skill of visual memory, crucial in the art of sketching, is built up through years of study and constant practical hard work.

Before the invention of photography, the great masters could only record and develop their thoughts through the sketch. A photograph can quickly and correctly record details, but reliance on it will dim your observation and ability to capture expression, so that emotions will be lost.

When we draw from life the scene may change or the subject disappear, requiring us to be able to draw from memory. When Wu Dao Zi was commissioned to paint views of 300 miles of the Yangtze River in the seventh century he traveled its length studying it carefully and painted the whole thing from memory on his return.

Drawing from memory is a very useful skill. When your eyes catch a beautiful moment, like a camera, immediately close your eyes and recreate the picture in your head to find out what it was that touched your heart. Draw it out as quickly as you can. You will find that all the unnecessary details have disappeared, leaving the the most important elements on the paper. Repeating this practice will improve your observation and your ability to transfer the details you want to the paper.

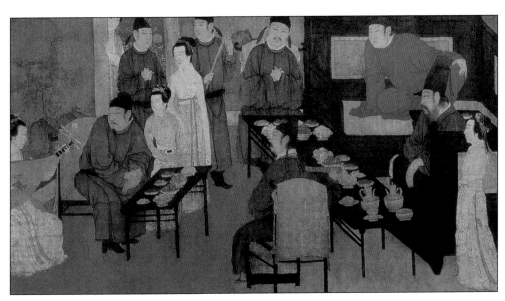

This is a small detail from *The Party of Han Xi Zai* by Gu Hong Zhong. When Emperor Li Yu heard rumors about his prime minister's decadent lifestyle he sent the artist Gu Hong Zhong to spend an evening with him. Gu Hong Zhong watched the party and later painted the night's activities from memory as a record of the events.

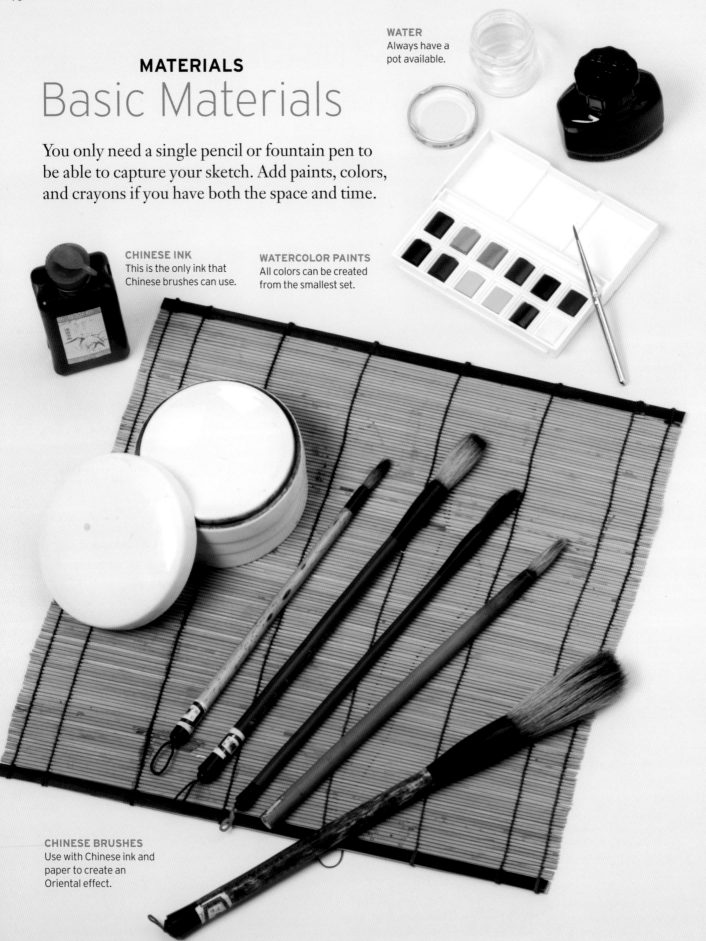

MATERIALS
Basic Materials

You only need a single pencil or fountain pen to be able to capture your sketch. Add paints, colors, and crayons if you have both the space and time.

WATER
Always have a pot available.

CHINESE INK
This is the only ink that Chinese brushes can use.

WATERCOLOR PAINTS
All colors can be created from the smallest set.

CHINESE BRUSHES
Use with Chinese ink and paper to create an Oriental effect.

FOUNTAIN PENS AND INK
Almost any scene can be captured by a single pen.

CHINESE FOUNTAIN BRUSHES
These combine many of the qualities of a brush with the ease of a pen.

BRUSHES
Normal paintbrushes can be used with watercolor, oil, and Chinese paints.

PENCILS
It is best to use soft pencils, ranging from 2B to 6B.

OIL PAINTS
These are useful when more time is available.

CHINESE PAINTS
Mix small amounts with Chinese ink to vary its tone.

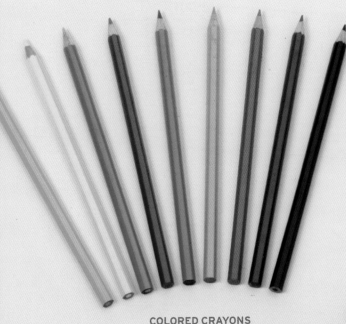

COLORED CRAYONS
The most convenient color medium.

Paper and Traveling Materials

Your sketchbook can be carried in your pocket but if you hope to sketch for longer have all your equipment at hand.

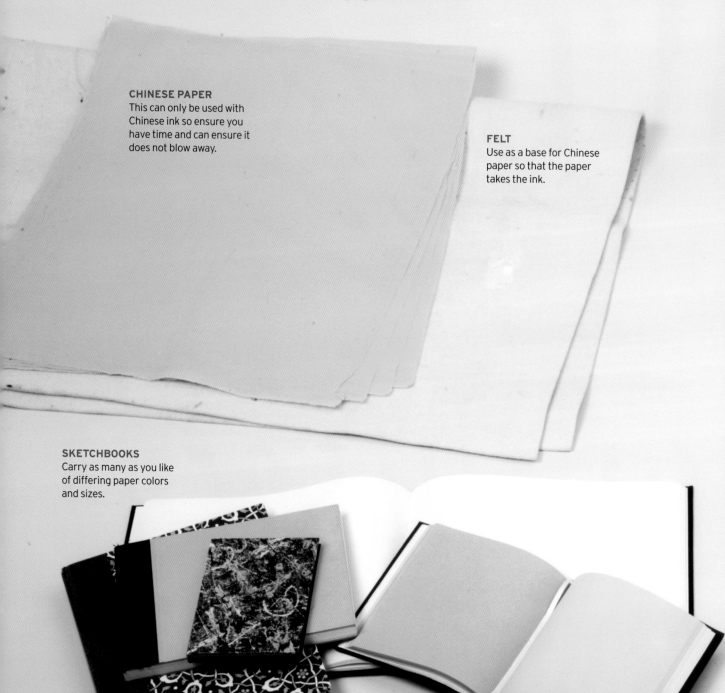

CHINESE PAPER
This can only be used with Chinese ink so ensure you have time and can ensure it does not blow away.

FELT
Use as a base for Chinese paper so that the paper takes the ink.

SKETCHBOOKS
Carry as many as you like of differing paper colors and sizes.

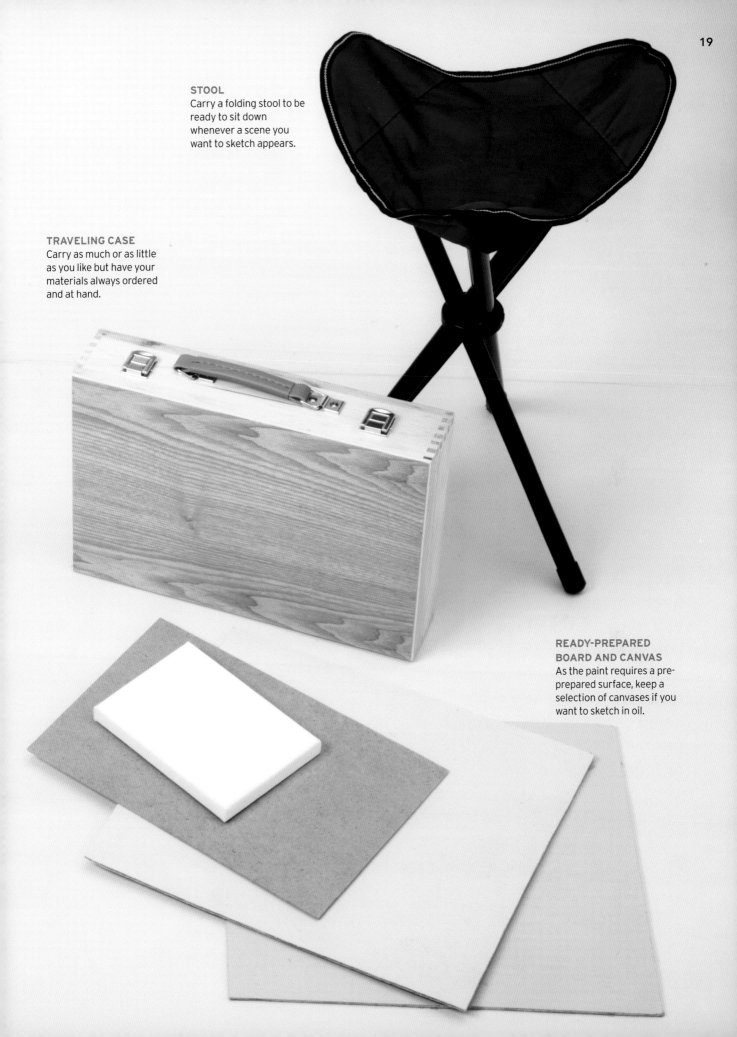

STOOL
Carry a folding stool to be ready to sit down whenever a scene you want to sketch appears.

TRAVELING CASE
Carry as much or as little as you like but have your materials always ordered and at hand.

READY-PREPARED BOARD AND CANVAS
As the paint requires a pre-prepared surface, keep a selection of canvases if you want to sketch in oil.

TECHNIQUES

Successful sketching requires two distinct elements to be combined: the understanding of how each medium works, and the ability to measure the amount of time you have available against the scene you want to record. In the end all your decisions on how to sketch will be regulated by the constraints of time.

Learning how to use the sketcher's tools and mastering their different effects gives the basic skills required. With that knowledge you can then decide the most appropriate way to capture a scene—if you have just five minutes, a pencil or pen is all you will have time to use, but if you have an hour you can decide whether you want to concentrate on showing a scene's colors using paints, or its textures, perhaps using a pencil, a pen, or fountain brush.

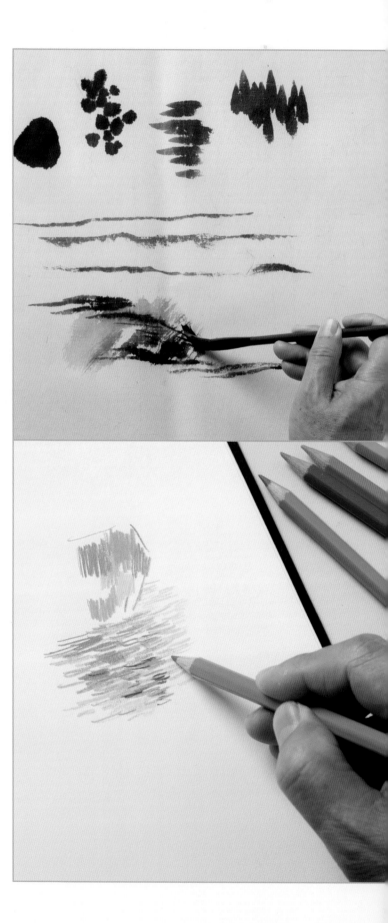

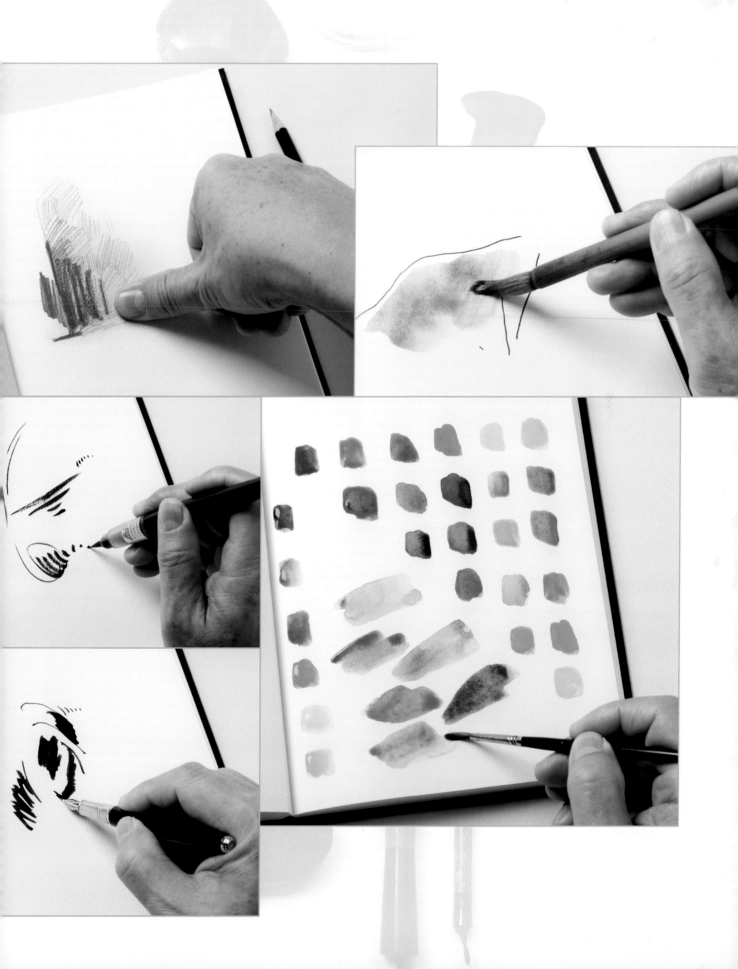

21

Pencil

Pencil is the most convenient and flexible of all sketching media. It can draw a line with almost every kind of effect—it can be heavy or light, thick or thin, dark or pale. It can draw very delicate, fine lines or large areas of tone. Additionally, you can rub pencil marks with your finger to produce very soft, subtle tone values, or use an eraser in the same way to produce highlights. In ancient times Chinese artists used charcoal, but nowadays the pencil is easier to carry and keep clean. I advise you to have at least two pencils prepared—a soft 2B and very soft 6B.

One pencil can make many different sorts of stroke.

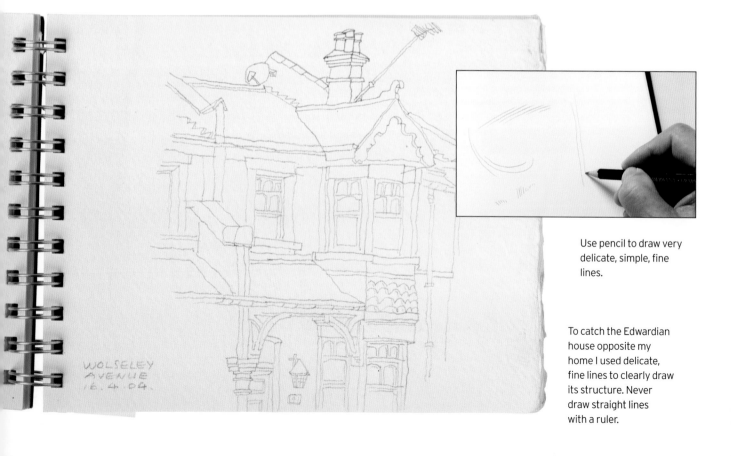

Use pencil to draw very delicate, simple, fine lines.

To catch the Edwardian house opposite my home I used delicate, fine lines to clearly draw its structure. Never draw straight lines with a ruler.

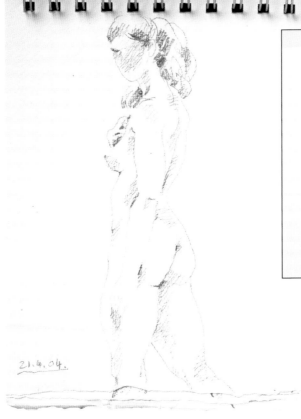

Use a pencil to make hatched lines that create shape, shadow, and tonal value.

Use a simple line to draw the shape of the body. Emphasize with a few hatched lines to increase the three-dimensional quality.

Pencil line can be very thick, and either heavy or light.

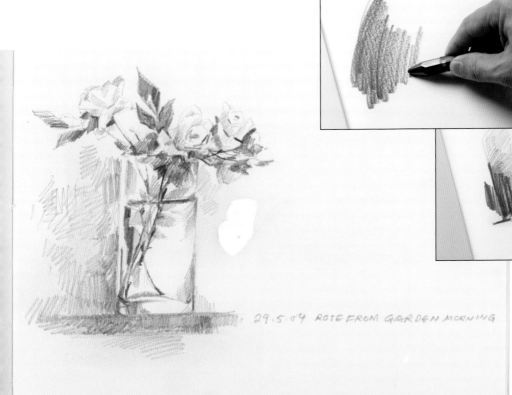

Use your fingertip to soften pencil edges and make them more subtle.

Combine long and short pencil lines with shading and areas of light, soft tones to sketch a bunch of flowers.

Pen

The most important thing to remember with pen sketches is to be positive and accurate because once you have drawn a line you cannot change it. This requires you to study the scene carefully before starting to draw. If you begin sketching with confidence and concentration, you're likely to get it right straight away, but it never matters if some lines are not correct—you can draw another one until you get the right one. By practicing pen sketches regularly you will quickly improve your skill at forming the objects you are drawing.

In China artists cleverly bend the tip of a normal fountain pen so that by changing the angle of the pen to the paper they can easily draw many different thicknesses of line. Also, most artists will carry more than one pen.

Don't forget that the ink might dry out, so always remember to take a little bottle of ink when you are preparing for a sketching trip.

Change the angle that you hold a bent-tipped pen so that you can draw different lines and dots.

However complicated or simple the scene, you can use different directions and sizes of stroke in groups to make the scene full of rhythm and life.

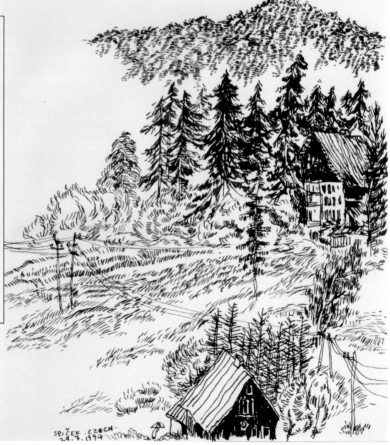

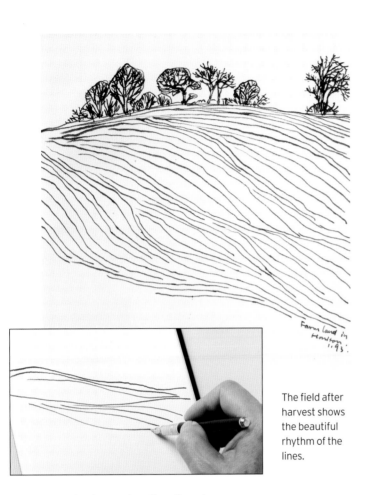

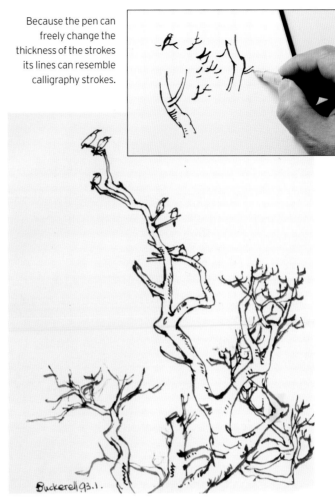

Because the pen can freely change the thickness of the strokes its lines can resemble calligraphy strokes.

The field after harvest shows the beautiful rhythm of the lines.

When drawing a series of long lines always remember the relationship between them—they are never single entities.

The calligraphy stroke is ideal for drawing a tree in winter, clearly showing the structure of the bare branches.

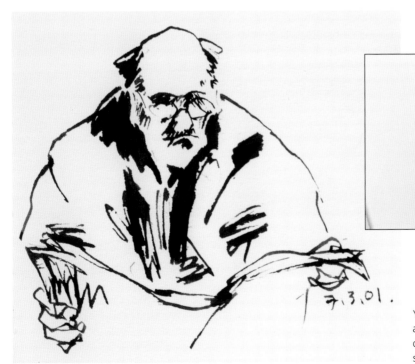

Held at certain angles, this pen can quickly draw strong and heavy tones.

You can capture character of a man on a train reading a newspaper by drawing only a few simple lines, and a few heavy strokes for shadow.

Chinese Brush

The great advantage of using a Chinese brush is its expressiveness, made by the combination of brush—big or small, thick or thin—brush hairs—long or short, soft or stiff—and ink—dark or light, dry or wet. With them you can draw any effect you like.

But it's worth remembering the inconveniences of using a Chinese brush: You must prepare more materials, such as special paper, felt to lay the paper on, brush washers, dishes, and ink stone or liquid ink. Particularly when it is windy or rainy a Chinese brush can make it impossible to sketch outdoors. Use the Chinese brush when you are close to home in good weather or when sketching indoors.

Use a big brush with thick, dark ink to make a big dot with a single stroke.

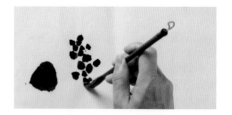

Use a smaller brush dropped straight down onto the paper to make what the Chinese call a "pepper" dot.

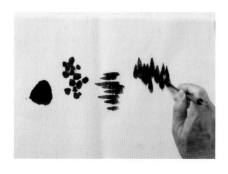

Change the brush angle and stroke direction to draw different long dots, which are ideal when used for tree leaves.

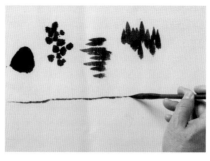

A line drawn with the tip of the brush following the line of the stroke is called the "central dip" brush. Move the brush as though you are holding a sword to cut into the paper.

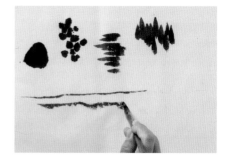

When you move the brush with the tip on the side of the strokes you can produce a variety of jagged effects.

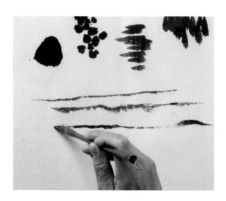

You can also push the brush, called the "opposite flow" stroke, to draw rougher, less polished lines.

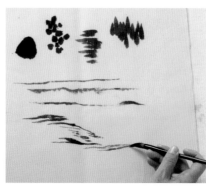

When you draw a group of lines ensure they share a rhythm between them, like a musical harmony.

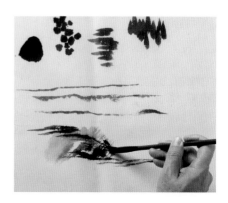

Before the mark is dry, use lighter ink on top, letting it run over the earlier strokes to make a very different texture. This is called the "crash ink" technique.

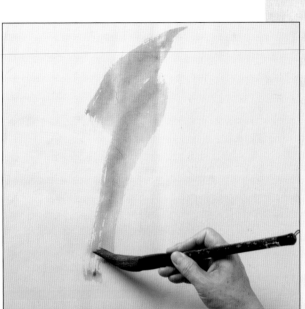

When using a big brush and light ink, paint with a fast stroke so that your internal feelings shine through.

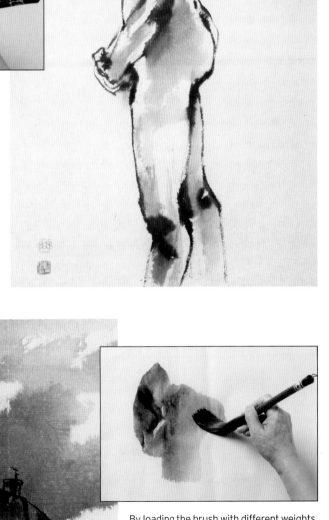

Changing to a stiffer-hair, sharp-tipped brush, use a fine line to draw the structure. You can also see where the different-colored wet inks have merged together to make new effects.

When painting clouds you must wait for the ink to dry before using a smaller brush to paint over the top, or else the inks will merge together.

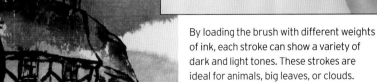

By loading the brush with different weights of ink, each stroke can show a variety of dark and light tones. These strokes are ideal for animals, big leaves, or clouds.

Crumpled paper produces a variety of textures, depending on the direction in which it is crumpled.

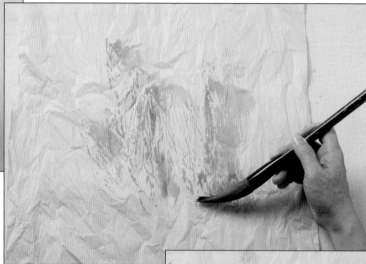

Use a big brush with pale ink to lightly sweep the background wash over the surface.

Immediately use darker ink and a smaller brush to draw the object.

The spring wood appears out of the early morning mist.

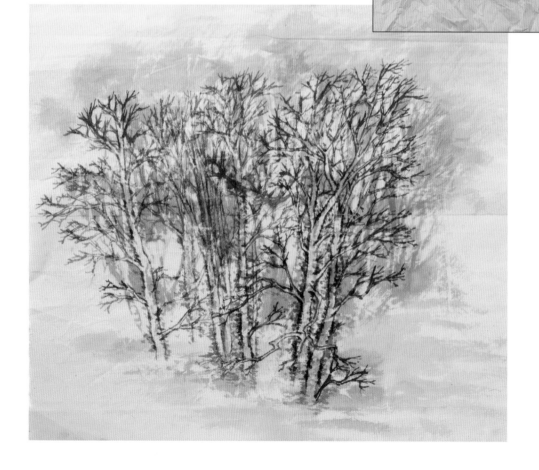

Fountain Brush

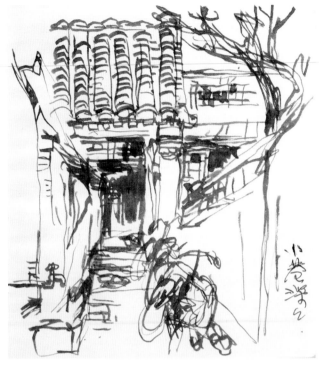

The fountain brush combines the advantages of the pen and Chinese brush. It retains the convenience of the pen—it is easy to carry and use—while its soft tip is more flexible, like the brush. But when compared with traditional brushes, the effects possible are quite limited. It cannot make big strokes and the color of the ink is set, so it is best to carry two or more fountain brushes, one with lighter ink, or even just water.

The soft tip of the fountain brush allows you to easily make many different types of lines and dots.

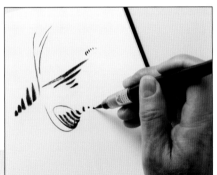

A few free, long strokes with some short lines, plus some heavy strokes in the shadow, are all that are needed to capture this Beijing alleyway.

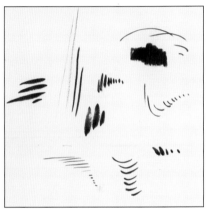

The fountain brush can imitate the light strokes of the pen, as well as the darker shades of the brush.

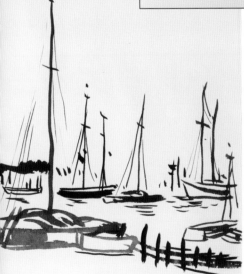

Use identical techniques for drawing lines and dots as with the Chinese brush, but carry only one or two fountain brushes in your pocket, and a sketchbook.

By adding contrast between dark and light areas you can produce sketches with more depth.

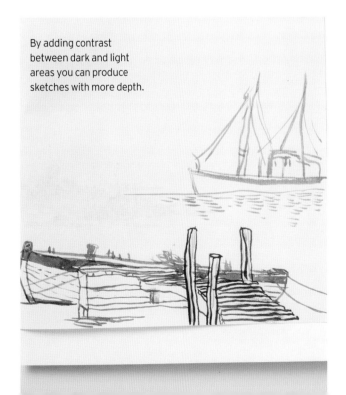

Pen and Wash

Sometimes you might not be satisfied with line sketches alone. In order to improve the quality of an object's surface, enhance the sense of light, or give a subtle change to the effect, you can add some wash over the drawing. You need to prepare one brush, some water, or even better a small watercolor set. When you do the sketch, use a few simple lines to draw the structure and movement and then use a brush to add a little wash. It often shows a more-interesting, unexpected effect.

A few lines draw the main structure of the mountain. Add a few heavy marks in the shadows, softening them with a few water strokes over the top.

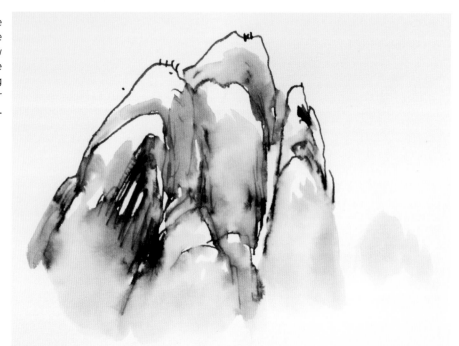

When water touches ink, the line spreads into subtle tones, all depending on the amount of water you use.

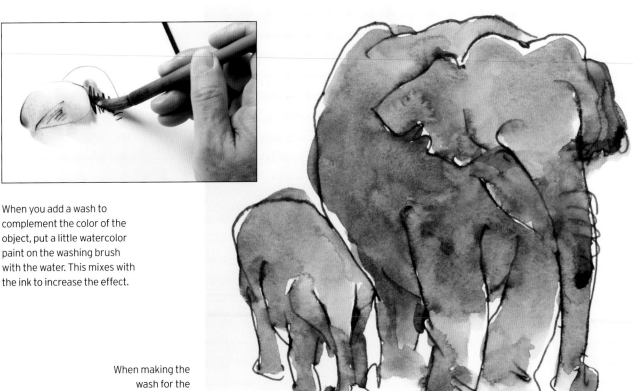

When you add a wash to complement the color of the object, put a little watercolor paint on the washing brush with the water. This mixes with the ink to increase the effect.

When making the wash for the elephant, I added a little indigo and burnt sienna to emphasize the skin tones.

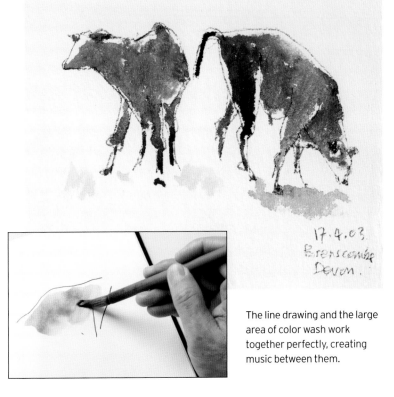

17.4.03.
Branscombe
Devon.

The line drawing and the large area of color wash work together perfectly, creating music between them.

If your sketchbook has good-quality paper it is even possible to mix the colors on the surface of the paper.

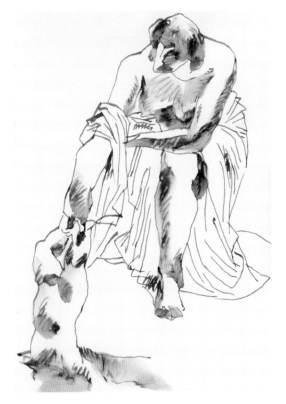

This sculpture of Achilles being made invulnerable by his mother Thetis uses wash over line drawing, the technique most commonly used in Old Master drawings.

Pencil and Color Wash

Using the same technique as a normal water wash but adding a little more color can make a very lively quality in the subject. It is also very quick: in Chinese we say, "Make half the effort to achieve double."

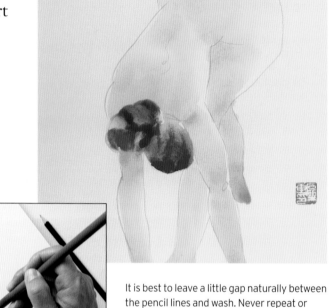

It is best to leave a little gap naturally between the pencil lines and wash. Never repeat or cover a stroke—you will only make a mess.

Use pencil to draw the accurate, delicate line and a soft Chinese brush to add a wash of burnt sienna.

Use the pencil line to record of the structural features. The color wash should do no more than record the colors.

This technique is very suitable for a quickly drawn life study. It catches the general mood of the scene: don't get trapped into trying to show every detail.

Many scenes don't need color wash everywhere; it is enough to catch only the interesting part.

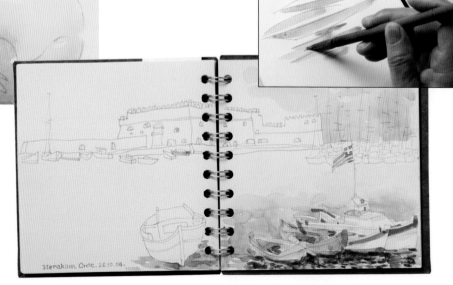

Colored Crayons

Colored crayons have the advantage of being clean and easy
to carry and use. Their main disadvantage is that it is difficult
to mix colors. In the natural world the effect of light means
there are no pure colors, so when using colored crayons be
prepared to use a selection of tones, with the main color in
the middle of these. Also, as you cannot mix colors, you must
learn how to cover one crayon with another.

Even though you cannot mix the
crayon colors on a palette, you can
mix them on the page by covering
one color with another.

A bright color contrast can be
shown easily in reflections on
the surface of water.

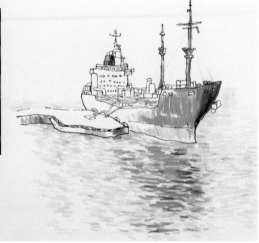

The reflections bring together the colors of the sky with those of the
ship's hull. Crayon is probably the best medium in which to capture
bright colors reflected in water.

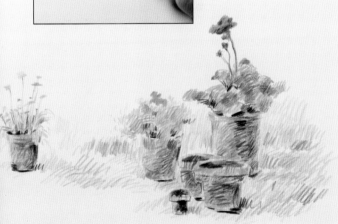

Use a mixture of colored crayons to
capture the contrast between warm
and cold tones under sunshine.

A few simple lines
and a little colored
crayon can make the
dullest scene into a
lively sketch.

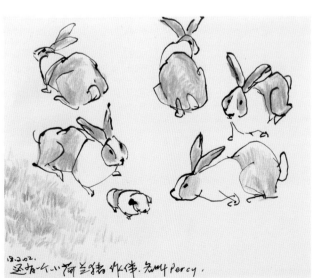

Watercolor Paint

Watercolor is one of the most popular media with which to sketch because of its convenience. You need only a sketchbook, a little watercolor set, and a bottle of water. At the very least prepare six basic colors: cold blue (French ultramarine), hot blue (cobalt), cold red (Alizarin crimson), hot red (cadmium), cold yellow (lemon), and hot yellow (cadmium yellow). In theory any color you want can be mixed from these six, but it can be very useful also to prepare a few middle colors, such as burnt umber, burnt sienna, ocher, and dark veridian green, which will speed up the mixing process.

Never use white and black when painting in watercolor: White can make other colors look muddy so just leave the paper blank, and in nature there is no such thing as pure black.

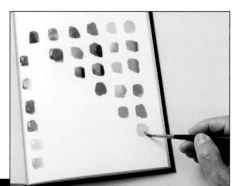

Make lines of the hot and cold reds, blues, and yellows and try mixing each combination to get many different colors.

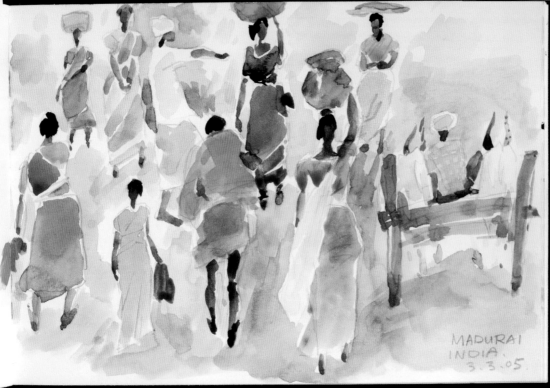

MADURAI
INDIA.
3.3.05.

India is a very colorful country. Watercolor paints provide the speed and convenience to capture the beautiful scenes and colors.

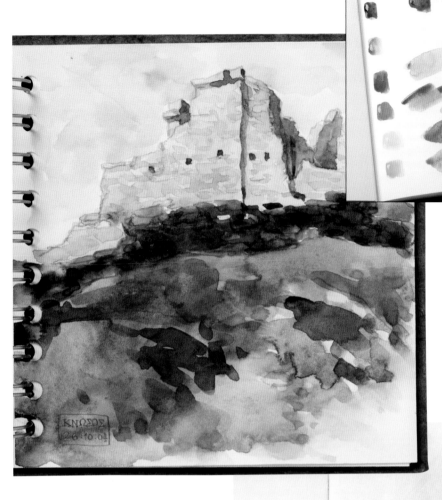

Each color's opposite, contrast color is made by mixing the other two primary colors—so the opposite of red is green, mixed from yellow and blue. To make a middle, gray tone mix the original color with a dash of its own opposite.

When I faced the ruined temple, it was bathed in the evening sun so I had only a little time in which to sketch. I captured the contrast in color and did not try to paint every detail.

With more time to capture this little mountain village in the peaceful, hot summer, I concentrated on the big contrast between the stone and tiles and was also able to study the many different grays of the shaded stones.

Oil Paint

To sketch in oil you need to prepare more materials and have more time available, both to paint and to clean up afterward. However, don't worry about these difficulties, as of all the types of painting, oil can most fully capture the beauty of nature. Therefore, when you begin a sketching journey, or if one day you have plenty of time to stay in a single place, it is a good idea to bring a set of oil paints. This should include a few brushes, around 10 colors, and turpentine in a well-sealed container. In many places you will not find art stores, so you should prepare some treated paperboard or canvas surfaces. A small easel and a little stool are also both very useful—there is always the chance you might miss a scene if you have nowhere to rest your canvas or to sit. Use similar colors to watercolor, but don't forget to include white paint in your set—it's a vital color when painting in oil.

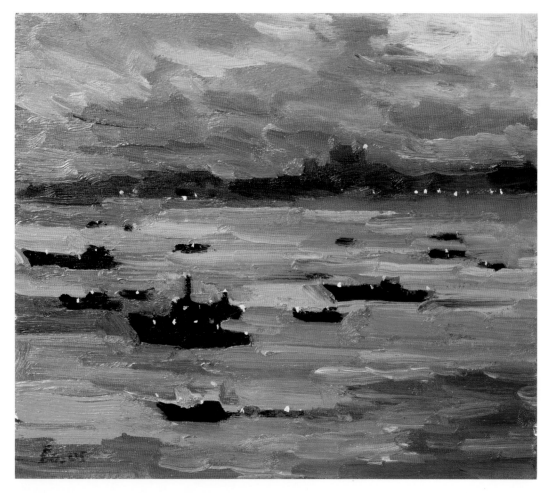

With dawn breaking over the Indian port, the light is changing every second. I prepared my materials and position before sunrise so that when the most beautiful moment came I could mix the colors and paint the sketch as quickly as possible.

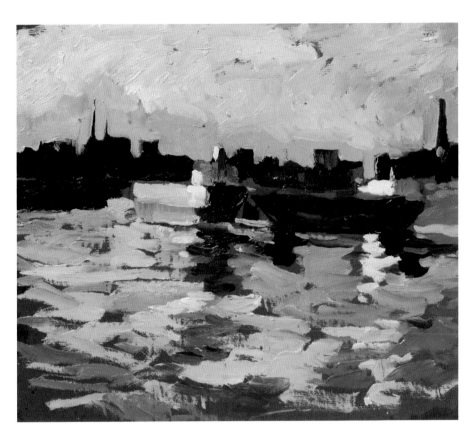

Preparing some colored canvas can give a better effect than painting directly onto a white surface.

Indoors, under electric light, you have plenty of time to study the light and color. But don't slow down because you have time—you should make your strokes sharp and fast. A sketch like this should be completed within a couple of hours.

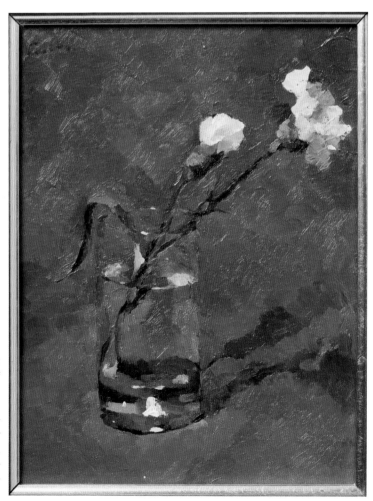

Using Time Effectively

TO MAKE A SKETCH I NEED TO KNOW:		
Subject (What to draw)	**Materials** (Which instruments to use)	**Techniques** (How to draw)
HOW MUCH TIME DO I HAVE?		

This chart is the a way of showing that when we are preparing to sketch the most important consideration is how much time we have. Only then can we decide what materials to use and how best to capture the moment. When there is only a little time we have to use it well, but when we have longer we can use different skills of observation and drawing.

The most crucial thing is to know roughly how long you have—whether it's a few minutes or a few hours. Then make it clear in your mind what you want to show, what it was that first attracted you to the scene, and sketch that. When facing a fascinating costumed figure, don't waste time painting the subject's hair, the least important part; or sketch a beautiful town but spend all the time painting the sky. Catch the important parts quickly and don't get caught up in everyday detail.

If, though, you have more time, observe the detail and immerse yourself in the scene. When facing the sea don't simply draw a few lines but capture the structure of the waves or the subtle color changes in the light.

The sketch has two purposes: the first is to record information from nature—shape, color, movement, and detail—which will bring the view back to life. Second, the sketch should be a good enough piece of art to frame and show—like many of the great Impressionist masterpieces. If you did not reach either of these goals, the sketch cannot be deemed successful.

When choosing which material to use decide what attracts you to the scene. If it is the shape, pick up a pen, pencil, or fountain brush to draw the proportions and structure. If the most exciting part is the color, use watercolors, oils, or pastels to capture the tones as correctly as you can. Again, though, time factors may dominate: If you only have five minutes you won't be able to use watercolor or oil paints. Instead you can use any convenient instruments like pencil, pen, or fountain pen to capture the general shape of a body, a movement, or even a detail like an earring on a pretty ear, or a baby's hand.

Look at the following pages to see examples of sketches painted under a variety of different conditions and time constraints.

A Short Time: 2-5 Minutes

If you only have a very short period of time, make sure that the tools you use and the view you sketch are simple. The pencil and pen are usually the best choices.

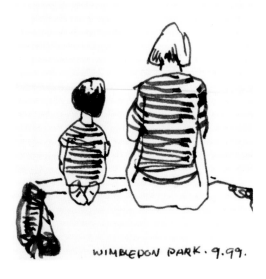

The tired passenger's sleeping position and the bags around his waist caught my eye. His figure and the airplane in the background tell the whole story—all other detail is unnecessary.

A few simple lines catch the figures' shapes and emphasize the bond between mother and daughter.

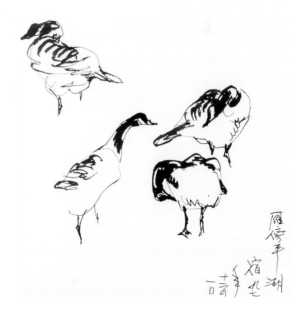

Passengers on the underground train are often either sleeping or reading a newspaper. As they are relatively still they can be easy to draw. Don't be afraid to sketch the people around you—they will normally be very friendly.

The geese keep moving, but practice catching the relationship between the head and the body, linked with a sinuous neck, and you will succeed.

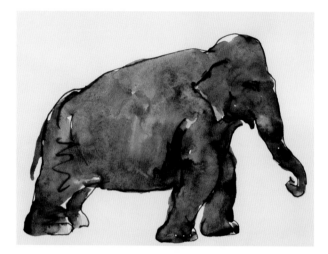

When I see an elephant, I feel its size and weight, so when sketching I emphasize these two points. It took just a couple of minutes to draw the lines, and back home I quickly covered them with color wash.

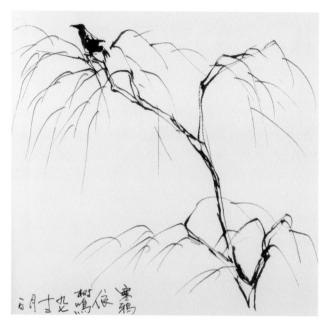

During the cold Chinese winter, a bird sits on the top of a willow tree. You can make the lines as simple as possible, but ensure you use enough to show it is a willow tree.

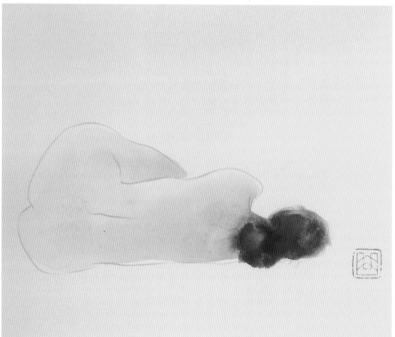

As this entire sketch will only take a couple of minutes, spend two or three minutes at the beginning looking and thinking. The large body is made up of only two or three lines. Then add the simplest color washes—one for the skin and one for the hair should be enough for a sketch like this.

Five minutes will be more than enough to catch the basic features of a traditional Chinese coal stove with chimney and kettle.

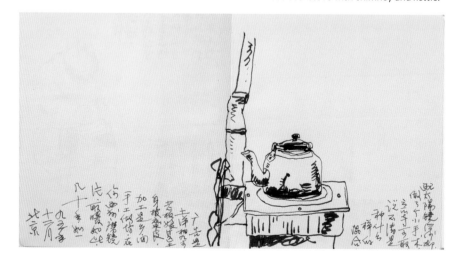

10-15 Minutes

With 10 to 15 minutes in which to sketch, you will be able to include more information. It is still best to use pen, pencil, or fountain brush to catch the general characteristics and relationships but you will have a little more time to add some background or detail.

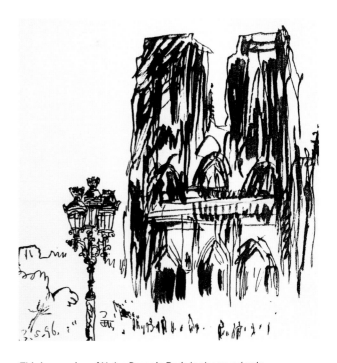

This impression of Notre Dame in Paris took around only 10 minutes. It was important for me to get three things: the magnificence of the building—it occupies two-thirds of the page even though it is in the background; the contrasting, ornate Louis XIV lamppost, that I put at the front of the picture, and the scale, shown by the insect-like tourists in-between.

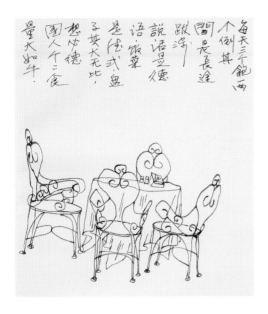

Sitting in a corner of a little hotel, I was enjoying studying the shapes of these beautiful iron chairs. It is important to draw the structure correctly, how the iron bends and how each piece is joined and welded.

The Grand Palace in Bangkok is very beautiful and very complicated, but I had very little time. I wanted to catch the general impression of the various shapes of the towers standing together, the flying tops of the roofs, but the complicated decoration is only hinted at. Although I didn't paint the detail I know it is there from my impression.

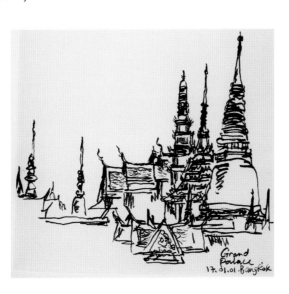

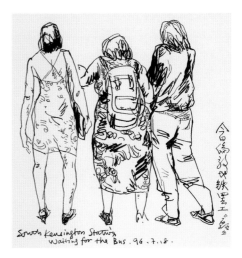

With the undergound trains on strike, the whole city stood on the streets waiting for the bus. I caught the frustrated feelings in the positions of the travelers' shoulders and necks. In this situation calm yourself down and enjoy the sketch.

20-25 Minutes

When you have 20 or 25 minutes to do a sketch you can get into some detail, add a simple color wash, or even paint a watercolor sketch.

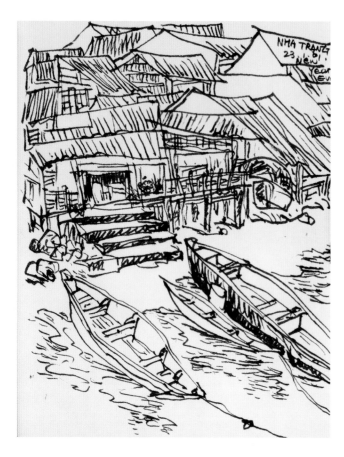

The Vietnamese riverbank village is created from many different kinds of line. The vertical lines of the wooden structures, the horizontals of the stairs, the diagonals of the corrugated roofs and the charming boats, and the little free strokes of the reflections on the river are unified together in harmony.

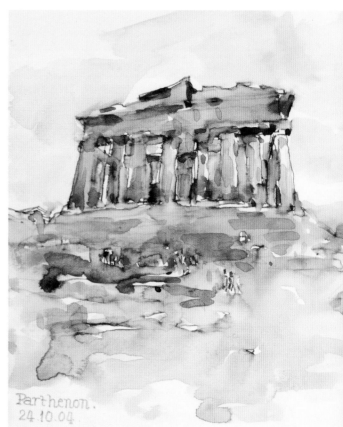

The Parthenon in Greece is magnificent and proud, standing on top the Acropolis in Athens. I quickly caught the strength of the building before adding a little bit of color wash, and used the small color dots of the tourists to emphasize the building's size.

Although dying, this late autumn flower remains beautiful. I used a fine line to draw the crumpled shapes of the flowers, stalk, and leaves. Even though it looks simple, the fine lines let me catch the essence of the image. Study the detail carefully and draw slowly. Carefully study the dying petals and the wobbly stalks and leaves.

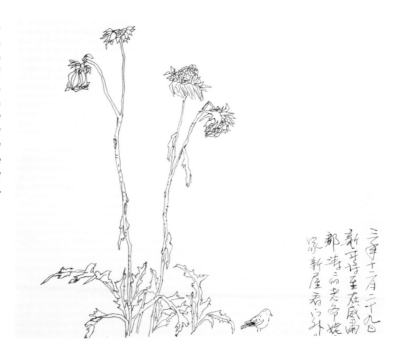

The Egyptian temple against the sunset shows the contrasts of the solid structure against the empty sky, and the dark, cold color of the stone with the bright, warm sunlight. Study the stone carefully to see the many subtle tones. Make the sketch more memorable by adding the tickets from your travels on top.

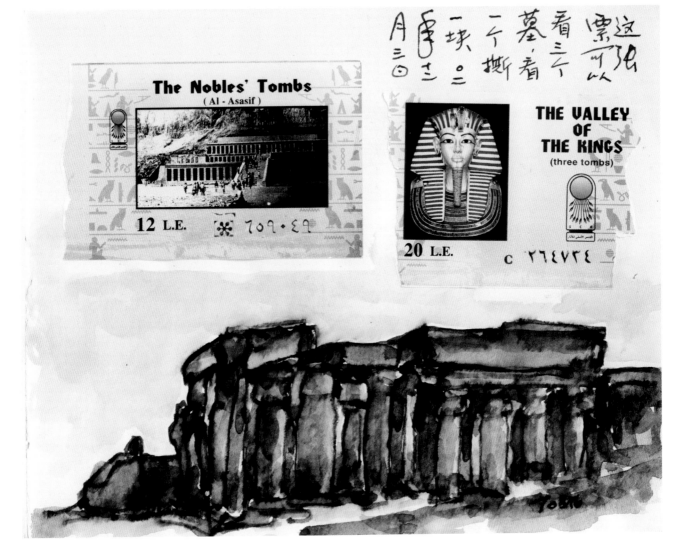

30-45 Minutes

This is a very good length of time to do a sketch. You can use almost any medium—decide by understanding which part of the scene really caught your attention. Facing the scene prepare your materials and take a few minutes to look carefully at what you are going to draw.

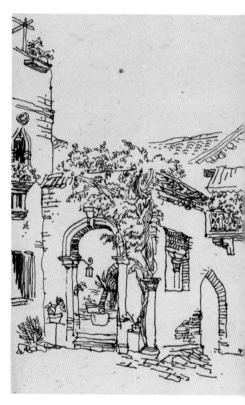

When I drew this little courtyard in Venice on a tranquil afternoon, my feelings were exactly in tune with the scene. I also had to be very peaceful, very quiet, and very calm to catch the atmosphere.

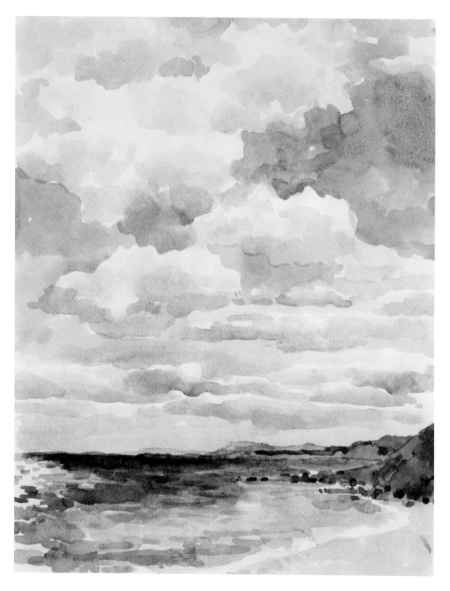

The sunlight is sparkling on the sea under the blue sky and white clouds. If you have half an hour or more you should have plenty of time to match the paint tones to the view. When the sunlight comes from different directions, the color of the seawater can be very different. Remember to paint what you see, not what you think you know.

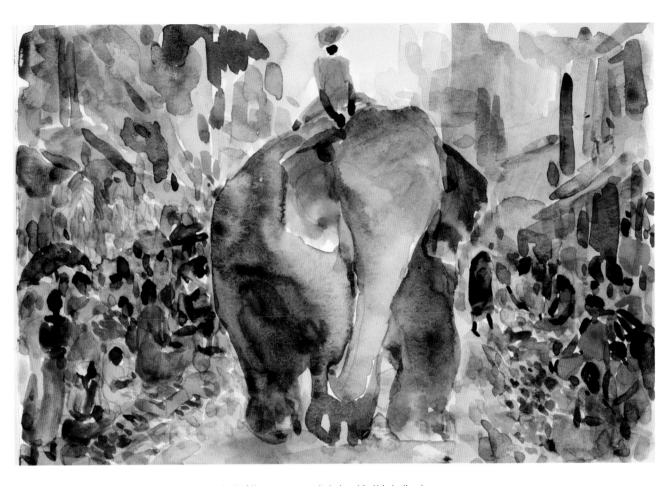

A policeman riding an elephant occupied almost all of the narrow market street in this Indian town. As they only took a few moments to pass me, I made sure I caught them quickly. Then I painted the market in the background at leisure—the women selling and shopping stayed much longer and kept relatively still.

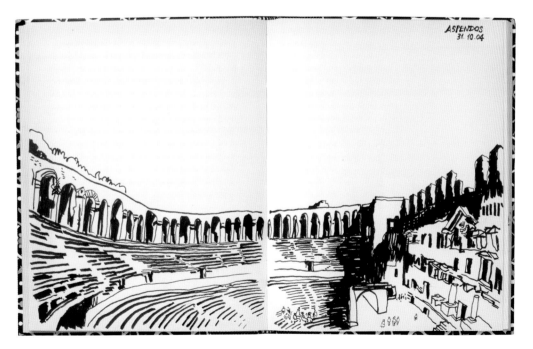

When I was sitting on one of the huge rock seats in this Roman theater in Turkey I felt the power, history, and genius of the ancient people. In this sketch I used two pages to show the magnificent view and the strong contrast of the light, adding little figures to give the view scale. It takes time to work out the perspectives and the structures of all the different elements, so sketch methodically.

60 Minutes

When you have about an hour in which to enjoy your sketching, you can really complete a whole artwork. The sketch should be well composed, from the general impression right down to the detail to catch the special features. You can use any media.

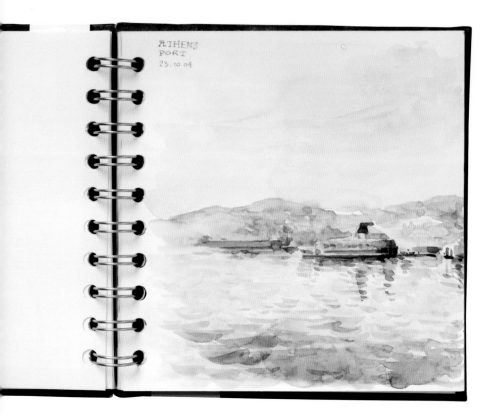

The Mediterranean seawater at dusk is an extremely charming color, but in the early evening the light changes very fast so you should first catch the general tones. When you get to the detail, ensure that the colors do not break that general tone.

When I look at a beautiful city for the first time, it is its history and culture that fill my heart. Drawing the roofs of the buildings and the towers of churches best captured that here. Across the sky I also wrote the story of what I had learned about the city.

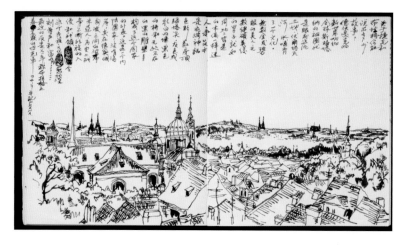

The picture is still but the seawater is moving, and ink is black but the light is bright. These contrasts required me to study the texture and the structure of the waves as they moved—they are actually very similar to mountains.

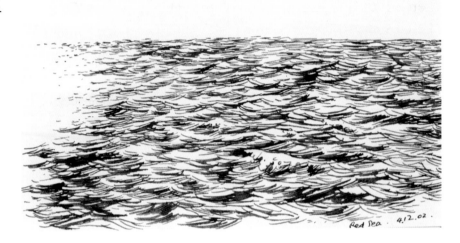

The shining light across the hot beach turned everything in front of my eye into all kinds of colored dots. Just let your brush and the colors follow what you feel.

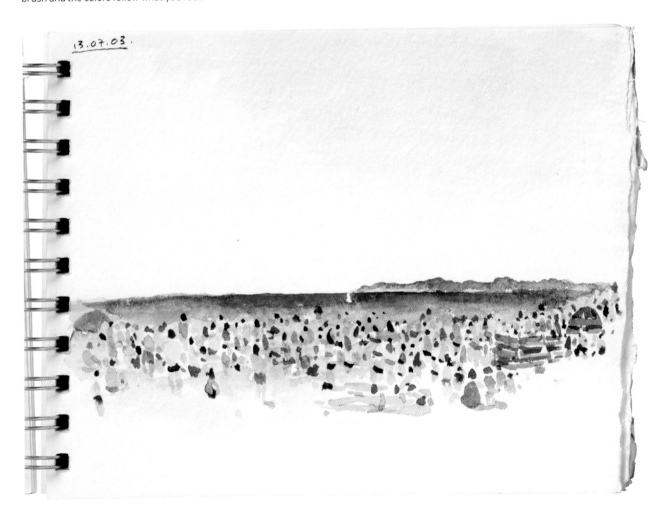

More Than 1 Hour

Having more than one hour means you have plenty of time to concentrate fully on sketching, with nothing else to bother you. You could set up your oil paints, or use any of the other materials. Remember, the purpose of each picture should be clear work quickly if you need to be quick, or slowly if you need to be slow. Don't waste time, but equally don't overpaint a picture just because time is available, as it is bound to be spoiled.

To paint a mountain village in Portugal on a bright, hot summer day, check that you have the colors mixed correctly and finish by placing the blooming, bright red flowers in the center.

In the evening I looked at the flowers and plants by my window, studying the way they were growing. This kind of sketch should be made leaf by leaf, plant by plant, pot by pot. Checking which lines cover the others and the connections between the lines are the keys to line drawing.

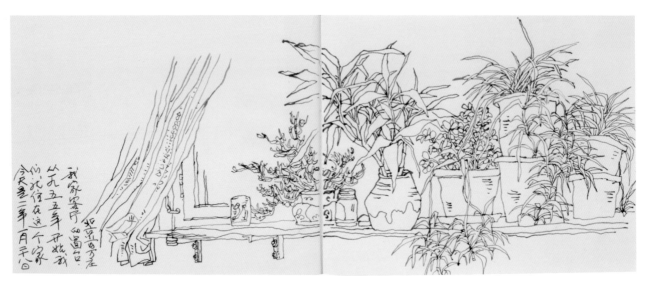

Looking out over the concrete and glass forest from my hotel room, I was surprised how much Nanjing had changed in the 20 years since my last visit. Never include ruled lines in a sketch, even when studying buildings. There is also no need to include every single window: Use different lines and dots to make boring structures more interesting.

In England there are many thousand-year-old treasures hiding in the countryside. When painting at dusk use color and composition to capture historic atmosphere.

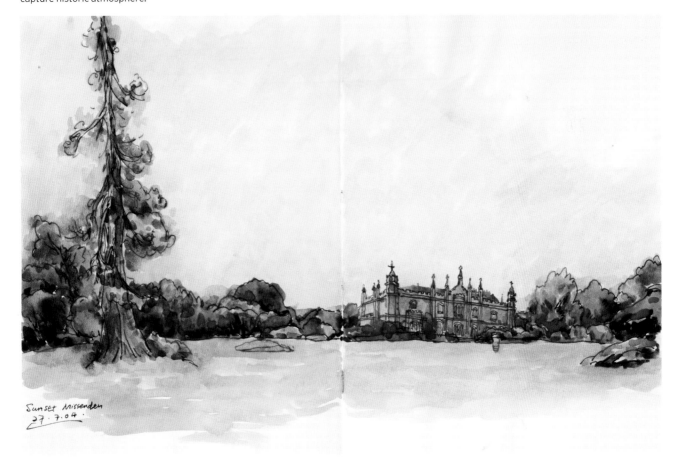

Capturing Movement

We can often be traveling on a bus, a train, or a ship and a scene will pass quickly by. If we are standing still, an object might move quickly out of view. In this kind of situation, when you are touched by something, don't let it go. Keep it in your mind and draw it—after trying a few times, your ability to capture movement will quickly improve. It is most convenient to use a pencil, pen, or fountain brush, adding some color if you can while your memory is still fresh.

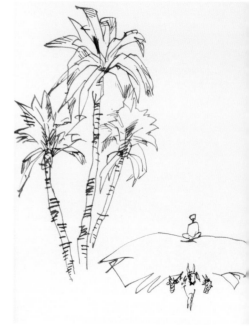

The man eating noodles on the train was constantly moving, but as long as the bowl, hand, and mouth are correctly related the sketch will succeed.

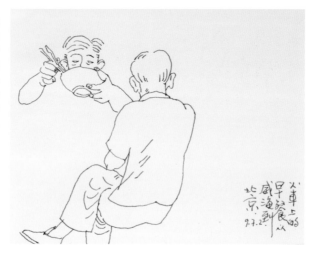

The Egyptian donkey was tiny and the cart with a man perched on top hugely overloaded. Quickly draw what you see before it disappears and then draw some palm trees to one side of the page to give context to the view.

The motorbikes are rushing past very quickly, but as soon as one disappears another one takes its place, so you can keep studying the way they move and put them together in a single image.

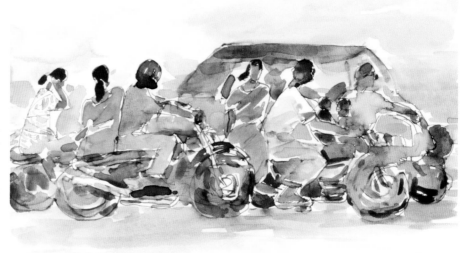

CHENNAI (MADRAS)
SUNDAY TRAFIC 27.02.05.

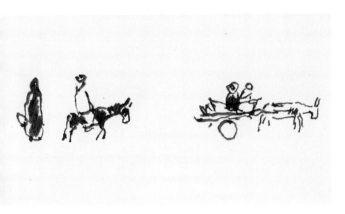

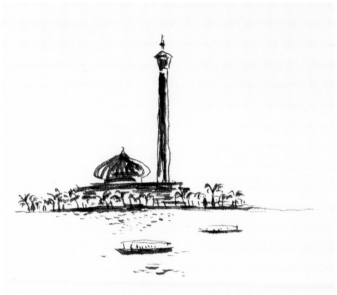

You can catch figures in a few very simple line and dots. Even though they are moving, they are repeating the same movement all the time.

Viewing the mosque in Dubai from a slowly moving boat you can catch the best positioning of the main building and the high minaret. Moving counter-clockwise, I painted the minaret and then the building, I placed a couple of boats in a suitable position to complete the composition.

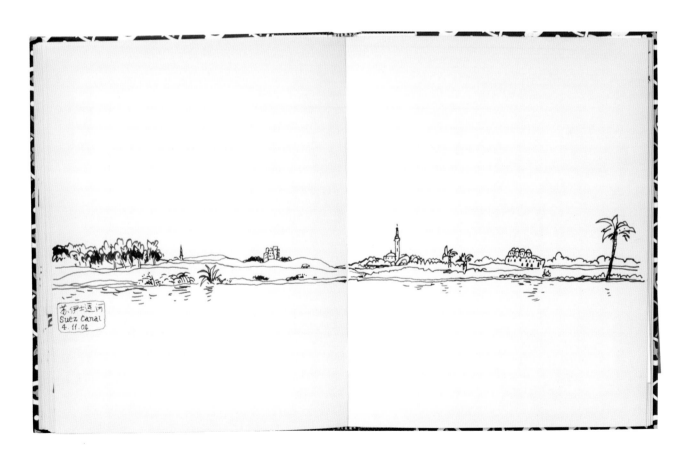

The view along the bank of the Suez Canal keeps changing while the ship is moving, but similar views appear all the time—a few trees, some houses, then a mosque, and then all over again. Just carry on putting in the scene as it appears. Remember, you are sketching an area's features, not drawing a map.

Visual Memory

On many occasions in life, a beautiful scene just suddenly goes past the eye and disappears. To catch what you have seen and draw it in a sketchbook quite often you have to draw from memory. To improve your visual memory of the detailed features of the things that you have seen, sketch by memory as often as possible. We can improve how much, how fast, and how clearly we can remember, our sharp observation of the natural world and our speed in capturing its features as well as improving how we record our observation on paper or canvas and our skill in organizing a composition. In the following illustrations are some very quick sketches, most of them done on a train journey. We should use our eyes just like a camera to collect a beautiful vision and transfer it to our heart. With our hands and materials we can then make our sketch.

Village with church tower

The light shining behind the buildings

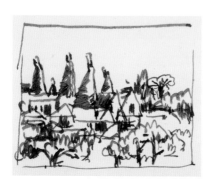

The roof shapes of the farm buildings

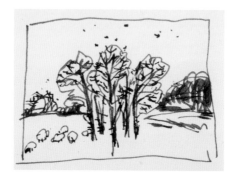

Passing farmland

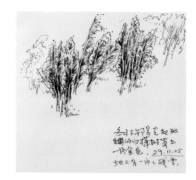

Golden birch trees in early winter

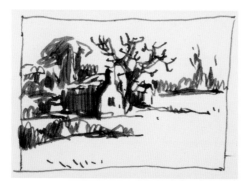

A huge oak tree in winter

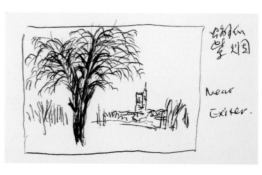

The interesting compostion of tree and village

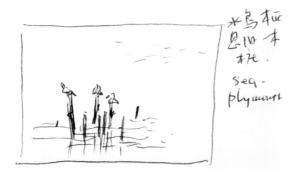

水鳥栖
息旧木
柱.
sea.
plymouth

Water birds rest on old posts

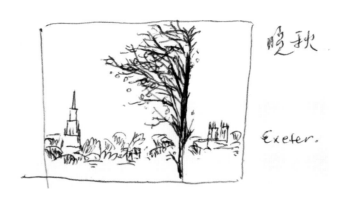

晚秋

Exeter.

Town with churches and tree blowing one way

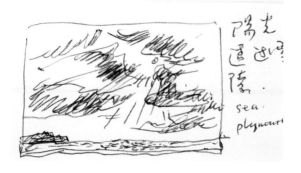

阳光
透过乌
陰.
sea.
plymouth

Seaside after a storm

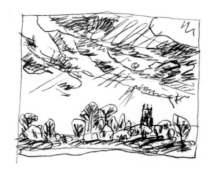

Classic view of cloud and sun

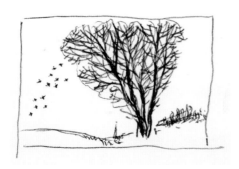

Birds returning to their nests in the evening

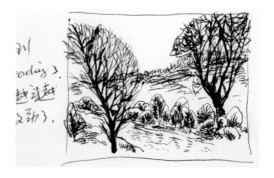

A little river

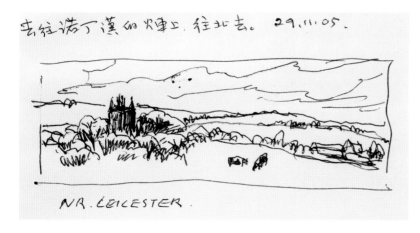

去往诺丁汉的火車上. 往北去。 29.11.05.

NR. LEICESTER.

A open landscape

A lake in early morning

Structure and Composition

The composition of every picture is as vital as the subject. The lotus flower here can be seen in bud, bloom, and when fading—each painted using different brushstrokes and techniques. With its theme of life, this sketch reveals the spirit of nature. The energy and verve of each flower, expressed in bold brushstrokes, comes first, with the structure and outlines being traced over afterward in fine brush lines purely to support the spirit.

LOTUS STRUCTURE
Avoid symmetry: Each large petal opens to the left, forward, or right. Note how the kink of the stalk, curving behind the foliage beneath, enters the flower.

WHITE LOTUS
Lotus bloom both red and white; valued as a contrast and sign of purity, the white lotus is often drawn as an outline only.

MAGNOLIA
Often seen accompanying lotus blooms. There are subtle differences between the species. Magnolia are smaller and thinner, with more pronounced calyces.

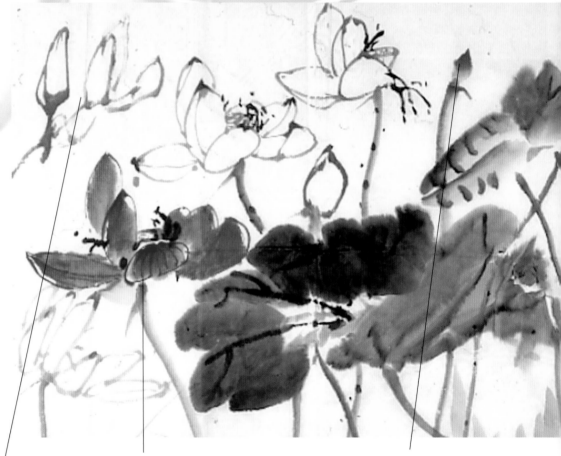

RED LOTUS
Use a few strong, expressive strokes to catch the life and the spirit of the flower; then run over the strokes with a fine brush to outline its structure. While the formation of the petal structure is unique to every flower, the structure, and a flower's position in a group, depends largely on its life cycle.

LOTUS STEM
As the petals fall, the stems curve and begin to droop beneath the flower.

SMALL LOTUS BUDS
Paint a new bud either in simple outlines or as a single freehand stroke of color. Keep the stalks as strong as the mature flowers.

DYING LEAVES

As leaves age show them drooping and losing their rich patina. These umbrella leaves need a big brush and splayed, splashed strokes.

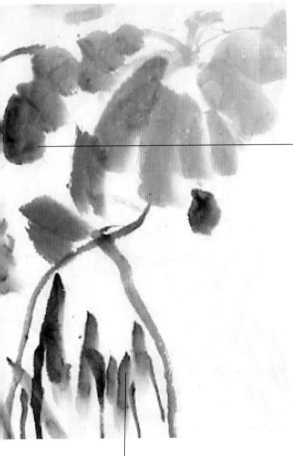

NEW SHOOTS

The youth of the new lotus stems rising from the water is emphasized by the dark ink, which fades to water ink only at their base.

MATURE LEAVES

When the lotus is fully open, highlight its size. Ensure that it is darker inside with a paler exterior. Group around their own stems.

YOUNG LEAVES

As the lotus leaves grow they change from a curled, cone shape into dark, flat planes, seen here from the side as the first side has begun to unfurl.

LARGE LOTUS BUDS

This bud is created using the same brushstrokes as the bloom above but does not use outline. Paint each petal with a single brush press, or stroke, in deep red to form the flower directly.

COLOR & COMPOSITION

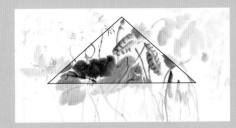

This composition is balanced by a simple structure. The triangle of lotus flowers pulls the eye across the sketch, and produces a balance that pulls the natural asymmetry of the stems together. The points of the triangle are highlighted in a single color, carmine red, traditionally the shade in which lotus are painted.

PATTERN & HARMONY

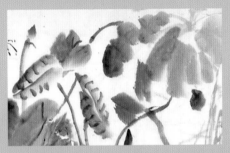

Here I have created a pattern of lotus buds using a single brushstroke for each bud. Because of this each stroke here is very important.

THE LIFE OF FLOWERS

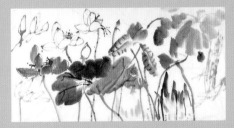

The theme of this sketch is life; the natural cycle of all living things. The flowers are shown in bud, bloom, and as they fade; but I have also incorporated symbolism in the choice of the flowers themselves. The lotus embodies a contradiction: Growing from dirt and mud, it blooms pure and clean. Taoists point out that seeing the lotus reminds us of the mixed moral nature of all living things.

PROJECTS: ANIMALS AND BIRDS

Nature created thousands of different types of animals and birds, and when you are looking at the history of human civilization, the earliest visual art—from cave paintings to early pottery—represents animals, recording people's earliest observations of the natural world. To make a good sketch of an animal or bird, it is first important to get its structure right. Watch and study animals carefully, as every animal has its own special shape and characteristics—the structure of its body, the proportions of its legs. However much the animal moves its basic structure will not change. Its mood and emotions are shown by its *chi*, which comes out of movement. Although this can be quite complicated, there are always some basic rules with which, when learned, we can all create good sketches.

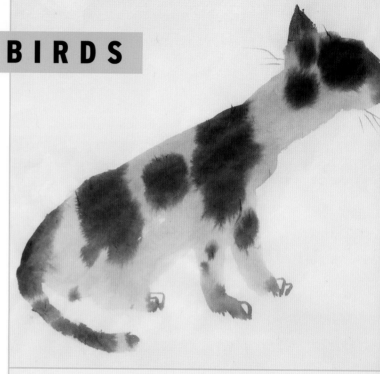

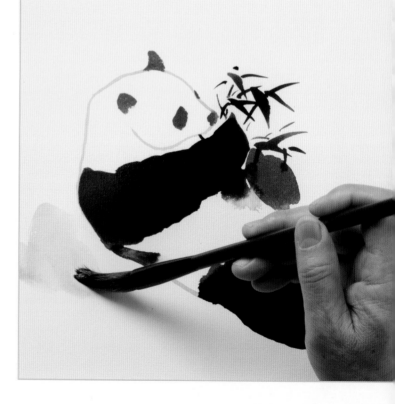

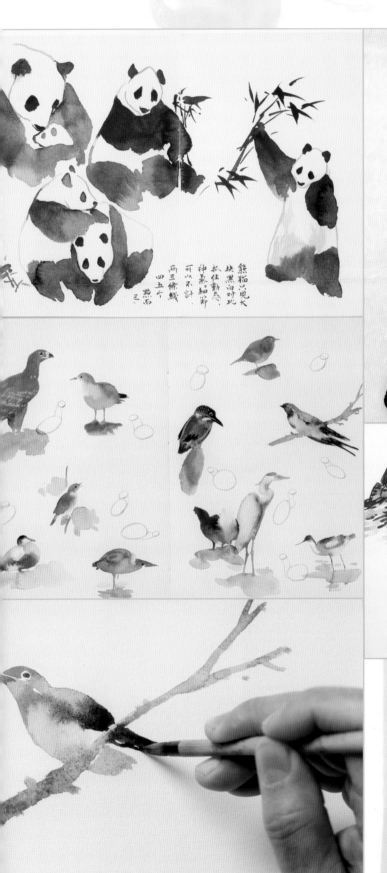

熊
猫
只
见
大
块
黑
白
时
比
抓
住
动
态
，
神
气
如
节
可
以
不
计
，
两
三
条
戟
四
五
个
黑
而
已
。

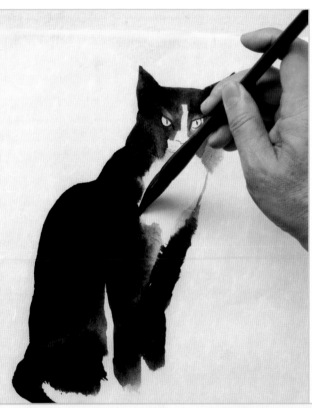

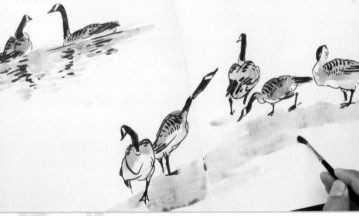

ANIMALS AND BIRDS:
Panda Inkwork

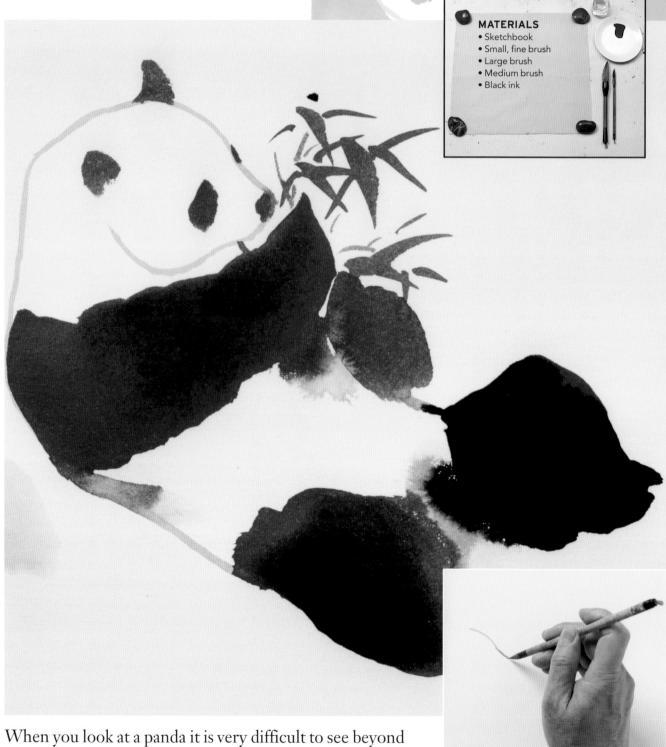

MATERIALS
- Sketchbook
- Small, fine brush
- Large brush
- Medium brush
- Black ink

When you look at a panda it is very difficult to see beyond the strong contrast between black and white. Instead, forget about the detail, if you can catch the movement of the animal, you can capture its spirit.

1 Start at the top of the panda's face from ear to nose.

2 Complete the shape of the heart-shaped head with a single stroke from the jawline up to the nose.

3 Continue the basic outline from the top of the head through the panda's neck to the top of its back.

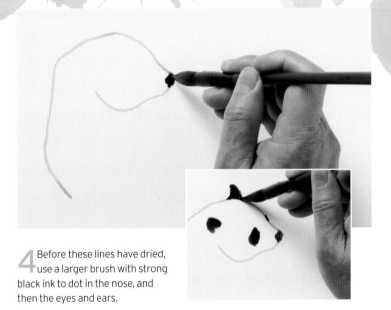

4 Before these lines have dried, use a larger brush with strong black ink to dot in the nose, and then the eyes and ears.

5 Use the same brush to make a thick black band inside the outline for the arm.

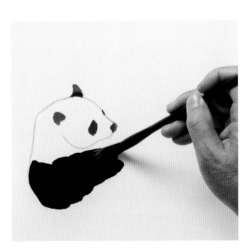

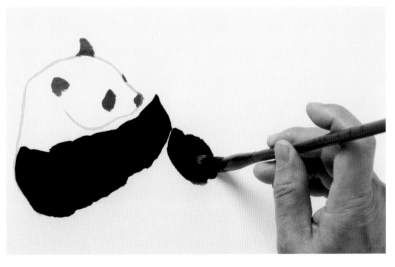

6 Make a group of vertical strokes across the panda's body to fill the width of the animal's black band.

7 Make one further large, dark dot stroke underneath the band to represent the panda's left arm.

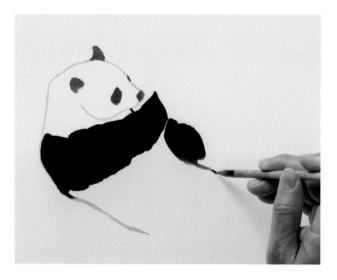

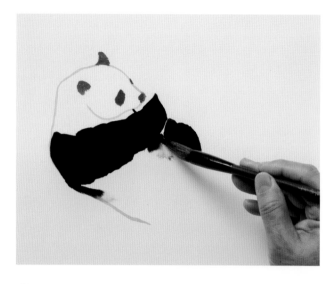

8 Reuse the thin brush to mark in more of the outline of the panda's body, using pale ink to contrast with the very dark areas.

9 Use a clean, damp medium brush to wash in water under the armpits.

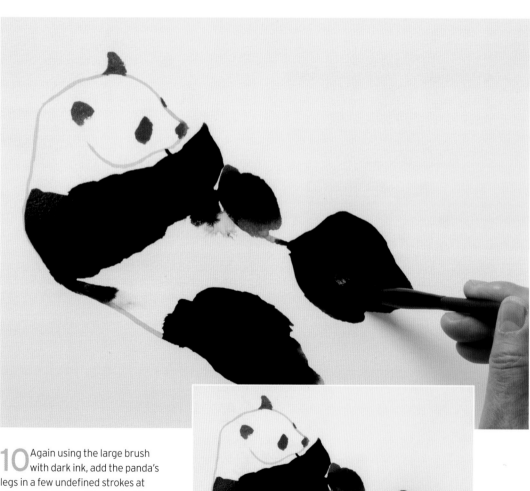

10 Again using the large brush with dark ink, add the panda's legs in a few undefined strokes at either end of the outline and add a wash between with the medium brush.

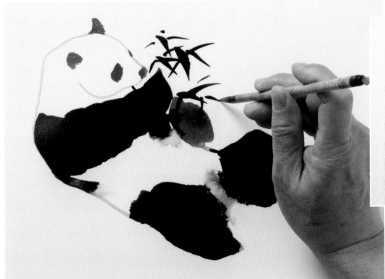

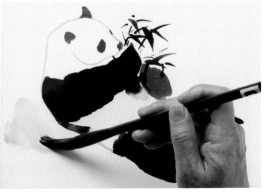

11 Put the panda in context by adding a small group of bamboo leaves with the small brush, and a patch of pale shadow with the medium.

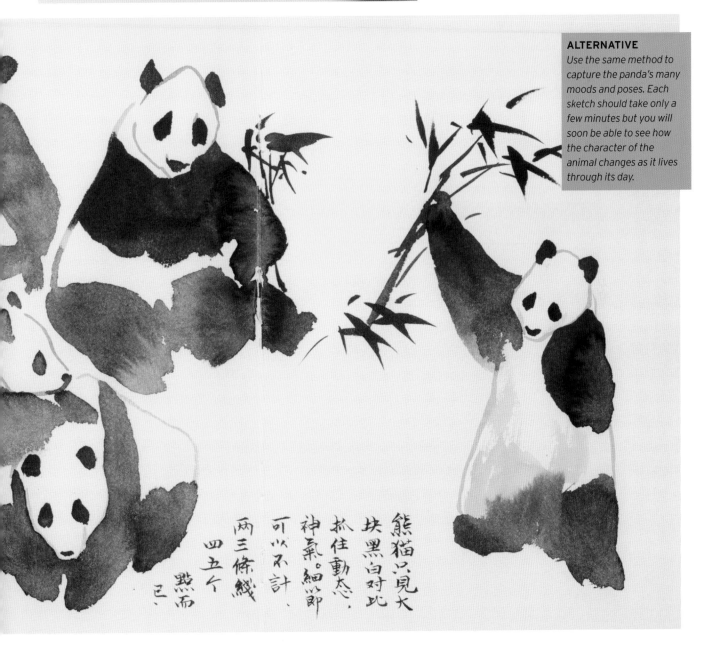

ALTERNATIVE
Use the same method to capture the panda's many moods and poses. Each sketch should take only a few minutes but you will soon be able to see how the character of the animal changes as it lives through its day.

熊貓只見大
塊黑白对比
抓住動态,
神氣。細節
可以不計、
兩三條線
四五个
點而
已。

ANIMALS AND BIRDS:
Swimming Geese

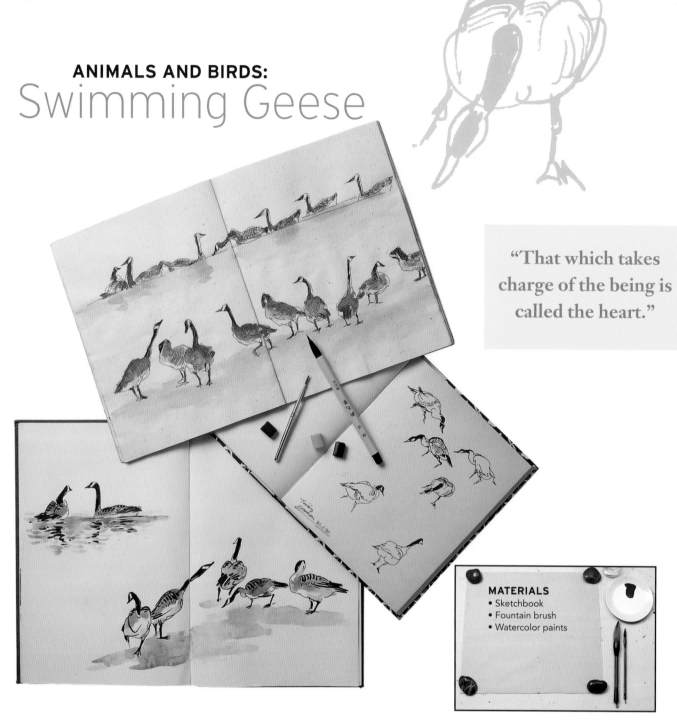

"That which takes charge of the being is called the heart."

MATERIALS
- Sketchbook
- Fountain brush
- Watercolor paints

Birds are almost always in motion, so when sketching you need to identify and focus on how their basic features are behaving to keep the anatomical composition correct. To a painter all birds consist of large and small egg-shaped ovals, which form the body and the head—the differences lie in their size, shape, and positioning. For example, the sparrow has two similar-sized egg shapes sitting very close to each other, while the crane has very differently sized ovals a long way apart. Capture a particular bird's character by combining these ovals with its individual features, such as its beak, neck, tail, legs, and pattern of feathers.

1 Always start painting a bird at its beak and head.

2 With the fountain brush draw in the shape of the goose's back and the water level.

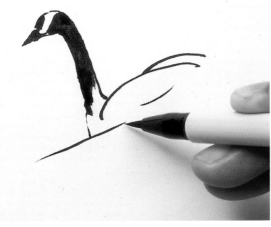

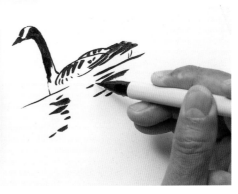

3 Paint in the feathers of the wings and tail and add the reflection in the water.

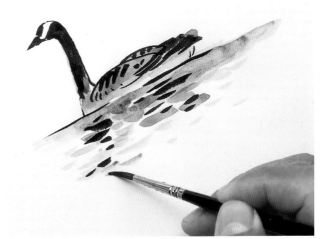

4 Mix burnt sienna and ultramarine watercolors to create the goose's coloring. Add a speck of blue-gray on its rump.

5 Use duller tones to create the bird's reflection.

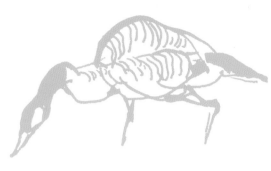

ANIMALS AND BIRDS:
Standing Geese

Tooting
Common 81.5.92.

<div>

PRACTICAL TIP

*All birds can be roughly divided into
air-feeding birds, land birds, and water
birds. For example, the water birds, such
as geese, swans, and ducks, usually have
long beaks, long necks, and short tails.
Land birds like chickens and pheasants,
usually have triangular beaks and shorter
wings; while soaring birds, like eagles and
swallows, have long wings, long tails, and
short necks.*

</div>

Although these geese are standing away from the water, they are still in
constant movement as they forage for food among the grass. Similar rules
apply when sketching birds on land so ensure that the size and shape of the
head and body are in proportion. Use a fountain brush or pen when dealing
with a constantly moving subject.

1 Start with the head and neck.

2 Add the outline of the body, this time a full oval, and the legs with the fountain brush.

3 Cover the bird with watercolor once more.

4 Paint in a unifying background wash that brings all the birds together.

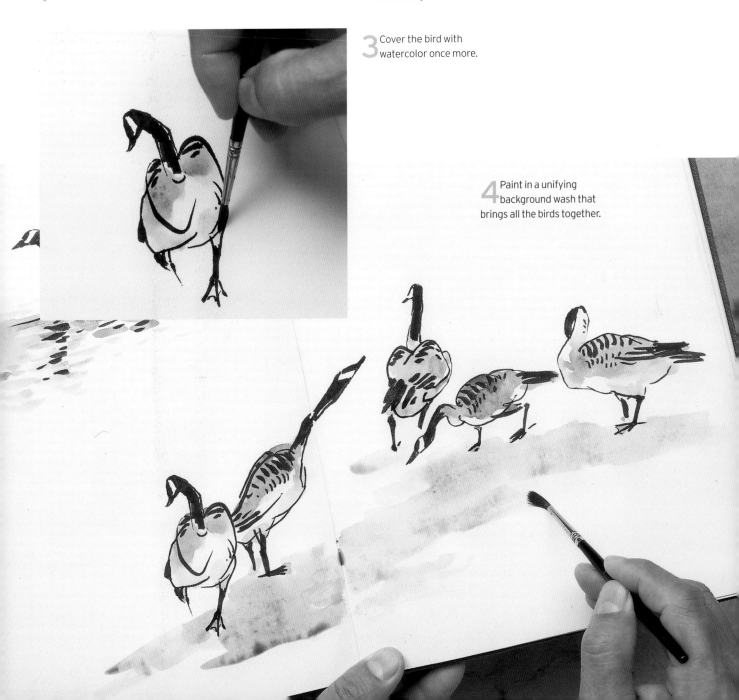

ANIMALS AND BIRDS:
Swallow on a Branch

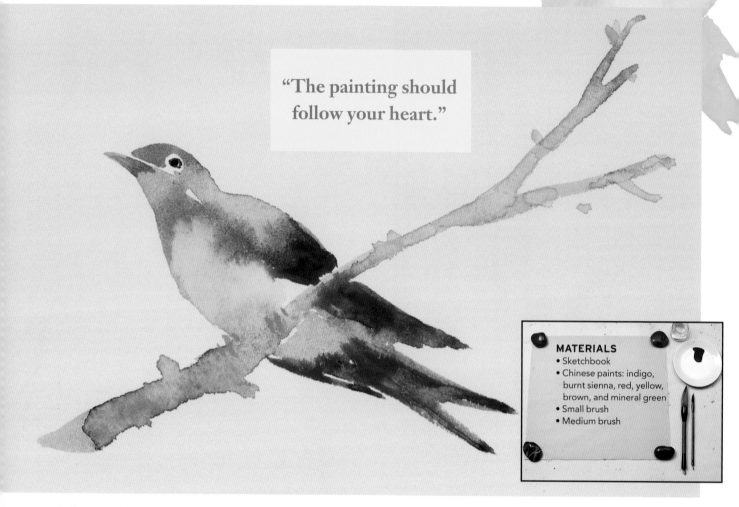

"The painting should
follow your heart."

MATERIALS
- Sketchbook
- Chinese paints: indigo,
 burnt sienna, red, yellow,
 brown, and mineral green
- Small brush
- Medium brush

The swallow is one of the birds that lives
closest to humans, returning with the spring,
nesting inside people's homes and underneath
the eaves; and in Chinese literature there are
many examples of the good qualities of the
swallow. Apart from the basic features that are
the same as other birds, the swallow has many
features of its own. Because the swallow flies
very fast, its body is slim and long, as are its
wings and its tail, which is split like open scissors.
The pink of its chest and neck is very beautiful.
As we paint each part we should clearly have in
our mind the overall shape of the bird, merging
them together into a single object.

1 Always begin sketching the bird at its beak,
making the outline in a mixture of burnt
sienna and indigo with a small brush.

2 Fill in the beak with the medium brush, adding a touch of red to the mix, and then place the eye slightly behind and above it.

3 Capture the swallow's forehead with the mixture of red with burnt sienna and indigo. Leave a gap around the eye to make it brighter.

4 Use a pale mix of indigo for the back of the neck and back, and pale red for the throat.

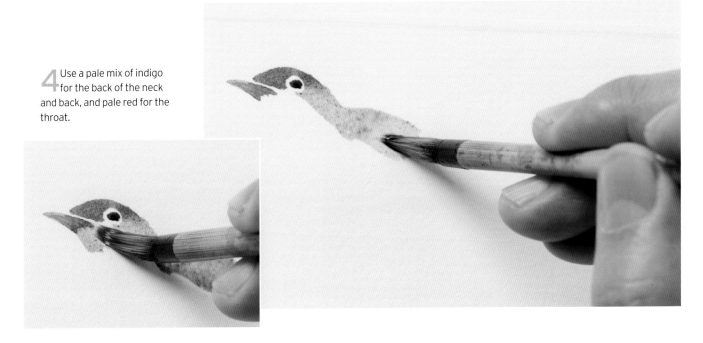

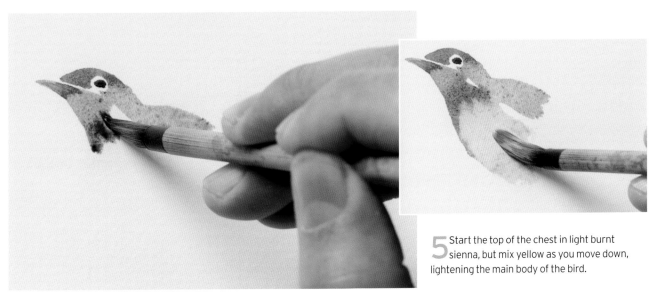

5 Start the top of the chest in light burnt sienna, but mix yellow as you move down, lightening the main body of the bird.

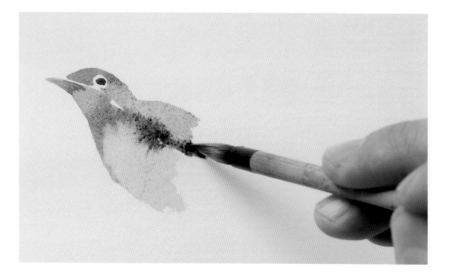

6 Mix a darker indigo to paint between the bird's back and chest, letting the color wash into the two. Also add it to the wing, enclosing the indigo color.

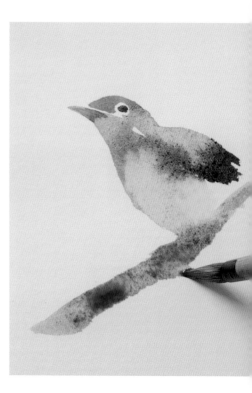

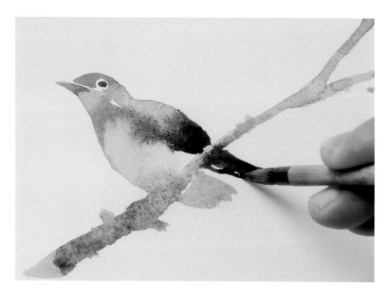

7 Paint the branch now, making it touch the front of the chest. Paint the main form in light ink, then highlight it with burnt sienna and touches of mineral green, adding the colors while the first strokes are still wet.

9 Return to a dark mix of burnt sienna and indigo to finish the wing. Don't worry if the color merges with that of the branch.

PRACTICAL TIP
Always start with the bird, never the branch. However perfectly you paint the bird, you will never be able to place it naturally on a previously painted branch.

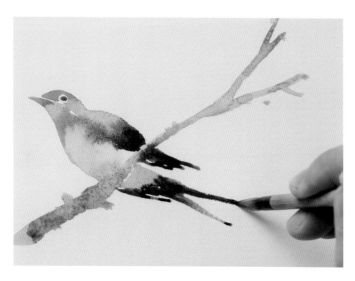

10 Add the long tails, ending each tip in a sharp point.

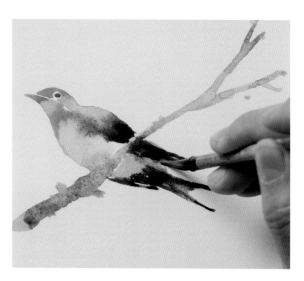

11 Wash the brush and use a pale indigo to join the two blocks of dark color.

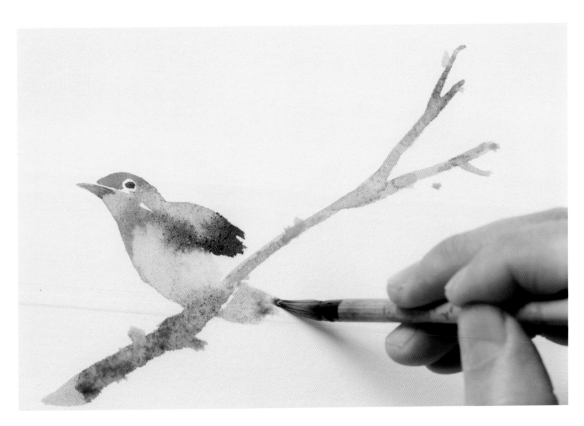

8 Continue the bird below the branch, giving it a pale brown abdomen.

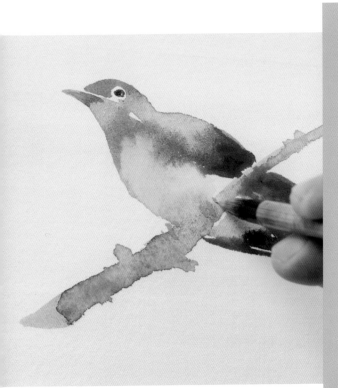

12 Let the sketch dry and finish by adding a reflection point to the eye and claws in orange and brown.

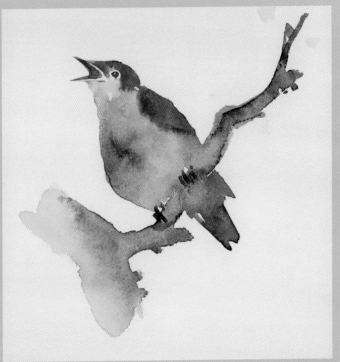

ALTERNATIVE
You can use the same method to capture any of the birds you might see in your garden—this nightingale was also sketched from the beak down and uses similar color combinations.

ANIMALS AND BIRDS:
Attentive Cat

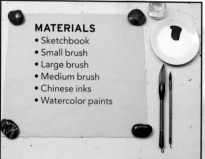

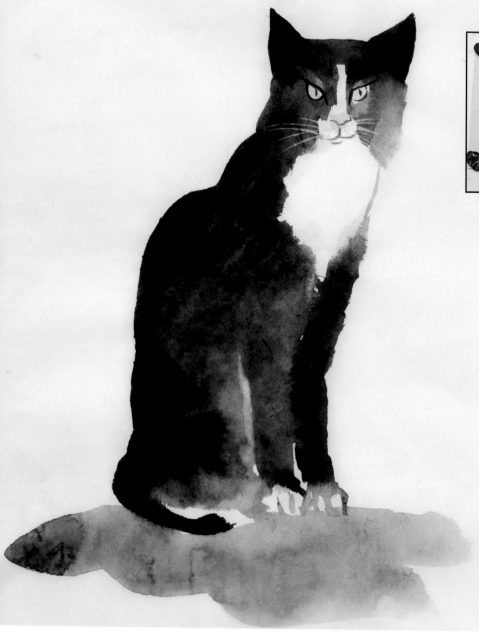

MATERIALS
- Sketchbook
- Small brush
- Large brush
- Medium brush
- Chinese inks
- Watercolor paints

1 Use a fine brush with black ink to outline the cat's eyes. The shape and positioning will be the center around which the whole sketch is painted.

If you have a pet it will be an ideal sketching subject: It will be ever-present, allowing you to capture it in any medium and with no time limit. The cat is especially good as its face and body language convey so much character. Once you have mastered the animal's basic form, use the *Tao* techniques to pare back the physical and bring out the cat's character.

"The success of a painting is decided by the first stroke."

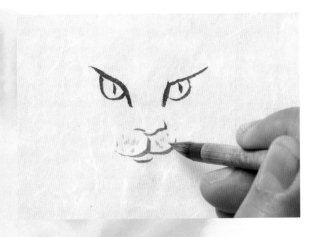

2 Mark in the mouth and add very light dots around it for the whiskers.

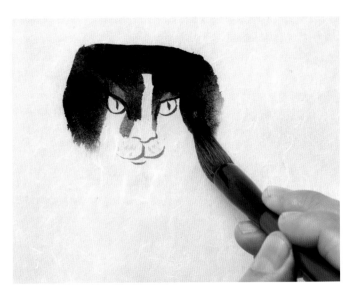

3 Change to the large brush and form the head from one thick horizontal stroke and one down each side of the head. Fill in above and around the eyes.

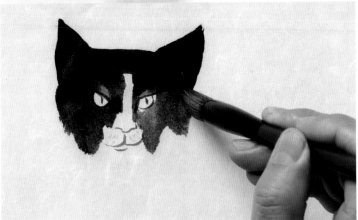

4 Add each ear with two strokes from the tip, thickening the brush as it reaches the head.

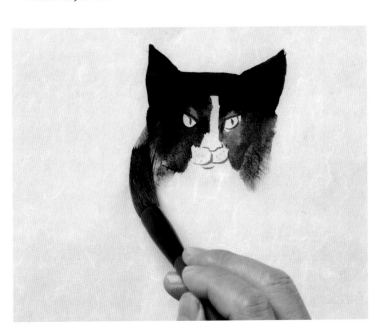

5 Use a paler wash of black ink to form the outline of the cat's darker side.

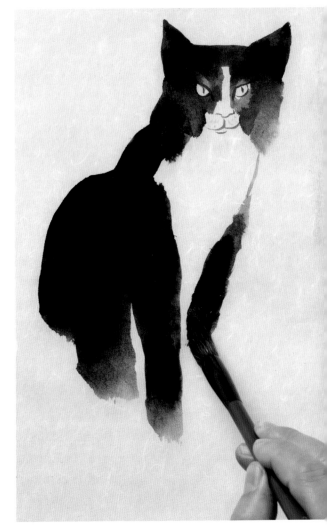

6 Fill in the body, tail, and legs with a few thick, solid strokes with dark ink.

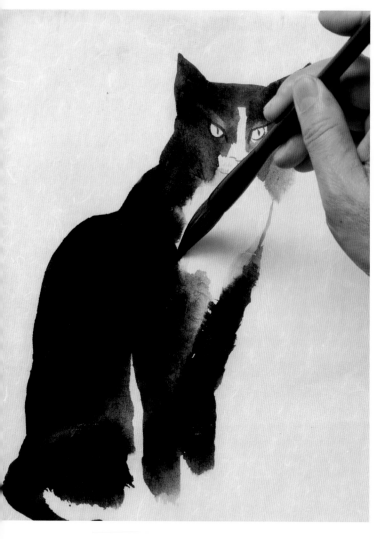

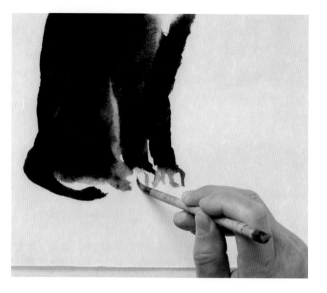

8 Use the small brush to include the claws—the only detail apart from the eyes and mouth the sketch requires.

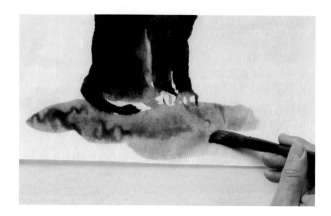

7 Take a clean medium brush and use water to wash lighter color tones up into the chest and between the front and back legs.

9 Position the cat on a ground of burnt sienna with a touch of ink, washed in quickly with the large brush.

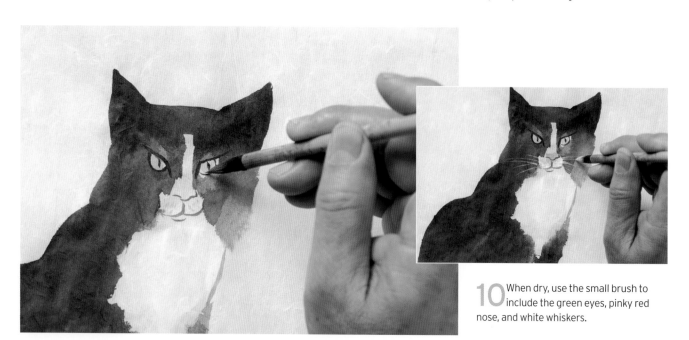

10 When dry, use the small brush to include the green eyes, pinky red nose, and white whiskers.

ALTERNATIVES
Use the same techniques to capture your own cat, whatever its color or character. The brown tomcat above is sketched in as limited a number of strokes as the black cat, but its shape implies it is ready to pounce on prey. The back view of the spotty kitten also gives the impression of a young and inquisitive animal—again achieved in only a few thick brushstrokes.

PROJECTS: PEOPLE AND PLACES

People and places are the most common subjects you are likely to sketch. First, you must decide what kind of people or places you will be drawing and which of their basic features you want to catch. In other words you must capture how they differ from other people and places. We should look carefully and catch those features, ignoring extra detail. Second, discover what kind of environment the people live in and what they are doing. Whether on the street, at the seashore, or at home, capture the relationship between the people and their environment. Third, introduce other elements into the scene to place it in context, giving ideas of the season, climate, time of day, or costume. All these are the basic elements of good sketching.

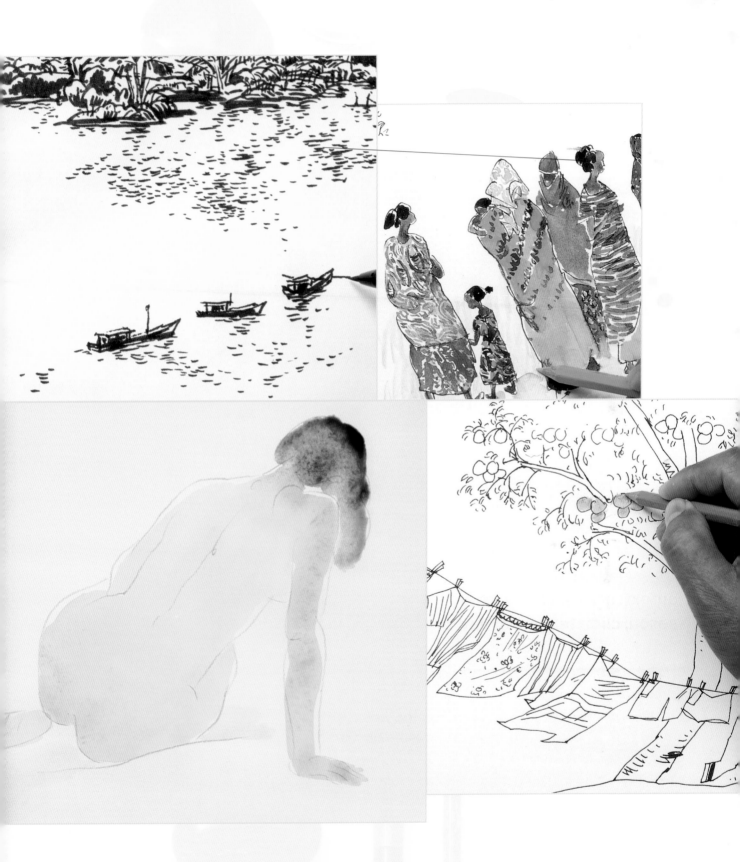

PEOPLE AND PLACES:
Beijing Breakfast

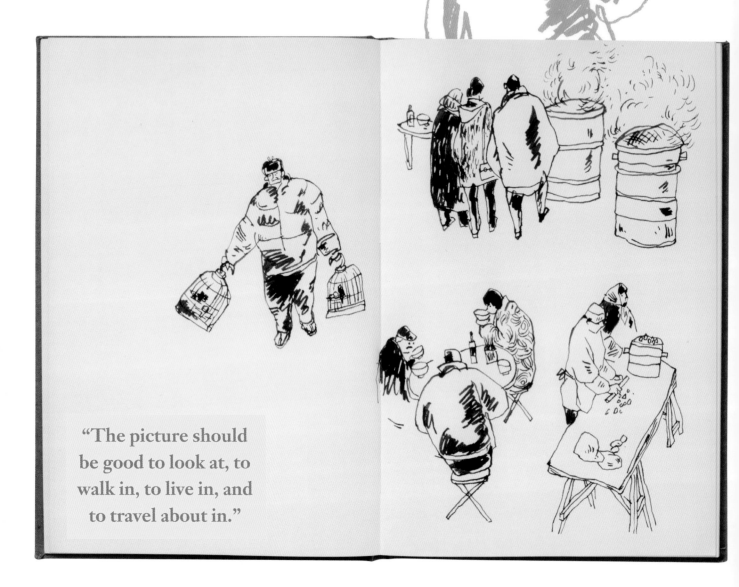

"The picture should
be good to look at, to
walk in, to live in, and
to travel about in."

Sitting quietly in the corner of a street market
allows you to capture people as they go about their
daily lives. Each person has his own interest, but
allow each figure to merge into a scene created in
your sketchbook. As a new figure joins the queue
for breakfast, include him next to the person who
has just left—allowing the scene to be captured as
well as the characters.

MATERIALS
• Sketchbook
• Chinese drawing pen

1 When you see a figure that interests you, draw his outline— filling in the gap between his arm and body last.

2 As another figure appears place her next to the first, even if he has already moved on, to give the impression of the thronging breakfast bar.

3 The third figure completes the scene. Use the same pen to create the figure's dark coat and trousers.

4 Sketch in the background only when you have completed the figures—this will still be there long after the customers have left.

5 Turn to another scene and again draw one figure at a time. Include the background at this stage if, like this round table, it will affect the positioning of any other figures.

6 The second man left quickly. It is not necessary to try to sketch any missing features from memory if the important parts of the figure are complete.

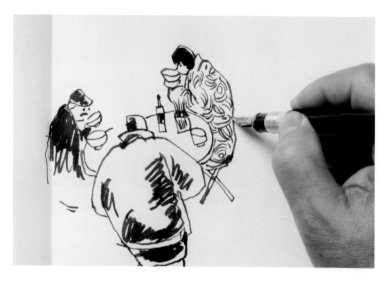

7 Capture the impression of the third figure's fur coat with individual pen strokes.

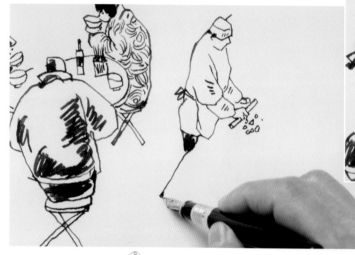

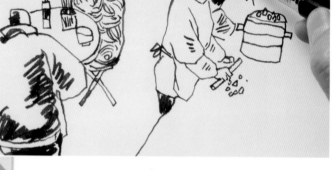

8 The third part of the scene—the food preparation—brings the other two views together.

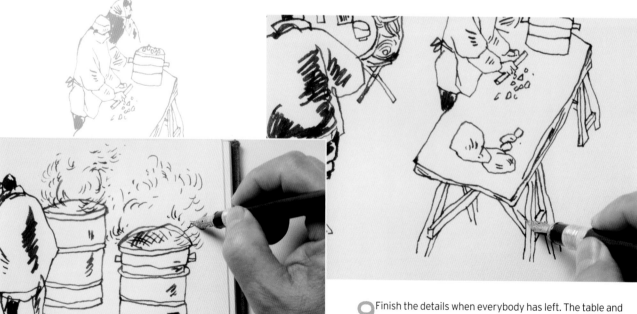

9 Finish the details when everybody has left. The table and second barrel unite the scene without needing to be sketched at the same time as the figures.

Man with Birdcages

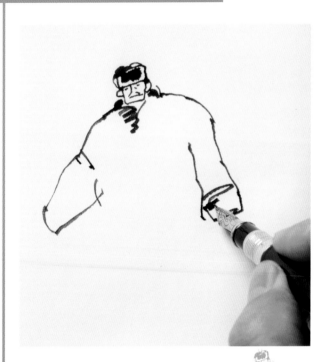

Even if you are intending to paint one scene, be ready to change tack if a particularly interesting view appears. The sight of men exercising their songbirds is still common in Chinese cities, but the sight of this old man walking through the market swinging two cages was irresistible.

1 Start with the man's face and continue with his broad shoulders and jacket.

2 Shade in the jacket to show its padding and draw one of the birdcages.

3 Now add his trousers and feet.

Early morning, cold wind, cold sun.
Swinging the cages covers
 everything with gold.
I am on the road I have grown up on
 since childhood.

4 Finish by including the second cage.

PEOPLE AND PLACES:
The Women of Djibouti

Vacations are great for improving sketching. Practice catching the essence of a fast-moving scene by working through these steps. While traveling in Africa I found the people extremely beautiful, but had only a very little time to capture them in a sketch as everybody—both myself and all the local people—were always on the move. To catch their special features and splendidly colored clothes. I began by using just my sketchbook and a single pen. Use words, or calligraphy, to describe as much of the detail of the colors, patterns, and design of the clothes. When you return to your room at the end of the day use watercolors to complete the sketch following the descriptions written earlier while the impression is still fresh in your memory.

MATERIALS
• Sketchbook
• Fine-line pen
• Watercolor paints
• Colored pencils

1 Use a fine-line pen to draw each figure's basic outline with a hint of the patterning of their clothes.

2 Add the second figure, the child, in the same way.

PRACTICAL TIP
You could use a camera to help remember a scene—but do not depend on it. The best way is to draw according to your memory. You will find the result more lively and your visual memory will also improve.

3 As the figures move away, describe the colors and patterning of their clothes, and any details you did not have time to include in your sketch.

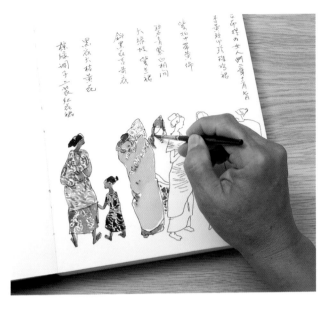

4 As other figures appear place them alongside the first group using the same method.

5 When you return to your home or hotel, paint in the colors and patterns of the clothes according to your notes.

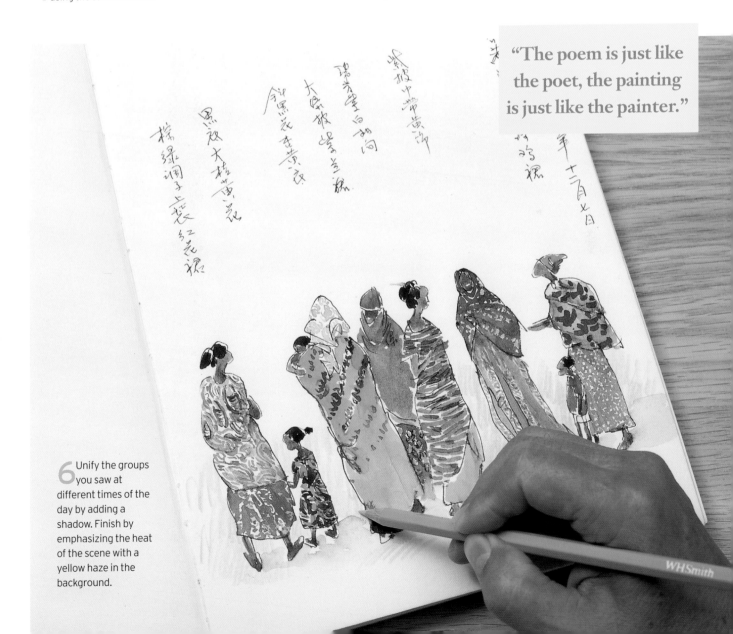

6 Unify the groups you saw at different times of the day by adding a shadow. Finish by emphasizing the heat of the scene with a yellow haze in the background.

> "The poem is just like the poet, the painting is just like the painter."

PEOPLE AND PLACES:
Cathedral Townscape

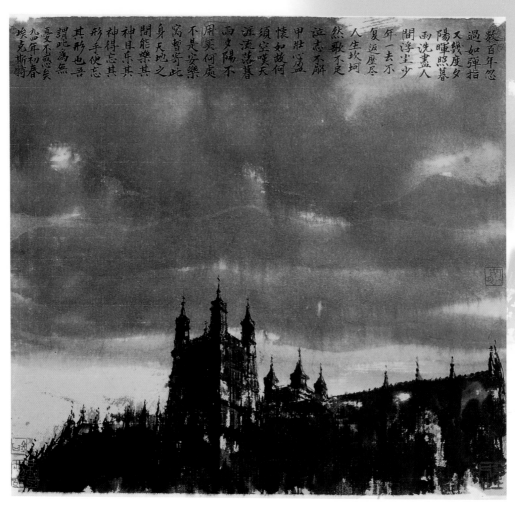

The combination of ever-changing cloud and light with magnificent architecture is very suitable for Chinese brush-and-ink work. You can use these techniques in a to paint movement, but first practice this project to help master the Chinese techniques. When sketching, simply prepare your materials on an old blanket—if it begins to rain you can roll it up and run for cover! Before you start take a long look at the scene to understand how the atmosphere affects your feelings. Then study the building's structure, to get an idea of where you will place it on the paper. Now decide on the stroke sequence—once you have made a mark you will be unable to change it, and from the moment the brush touches the paper you must not break a line until it is complete.

> "The brush should follow the spirit: When finished the soul should remain in the picture"

MATERIALS
- Large sheet of sketching paper
- Paper weights
- Black ink
- Water
- Large, soft brush
- Small, stiff brush
- Blanket

1 Set up your equipment on a blanket and use the tip of the large brush to mix black ink with water in a saucer.

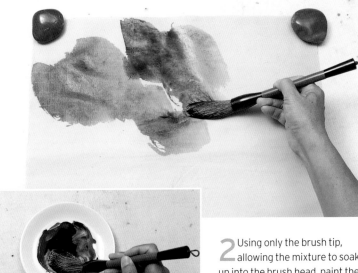

2 Using only the brush tip, allowing the mixture to soak up into the brush head, paint the layer of cloud nearest to you at the top of the paper.

3 Soften the clouds with diluted ink, letting the paler ink wash the edges, then paint in the next layers of cloud. Paint the last, palest layer of cloud along the bottom, allowing it to bleed downward to show falling rain.

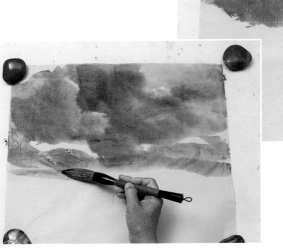

4 Choose the highest part of the building—the point the Chinese believe leads to the Gods—as the start, the point that is also the center of the perspective.

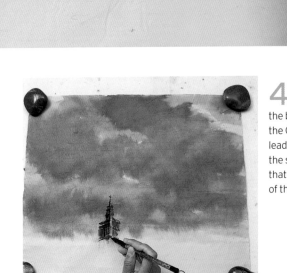

PRACTICAL TIP
You could paint the cloudy sky separately, or an hour before you start the buildings. This can make the sketching easier: when the cloud ink-work is wet, you cannot control it properly. Alternatively, create a stock of prepared paper.

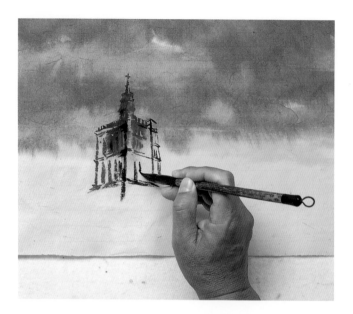

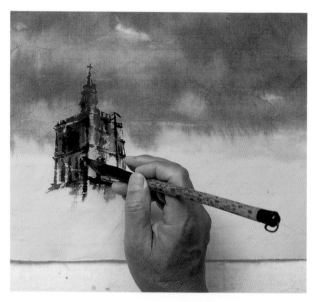

5 Use the stiff brush with dark ink to outline the building's main structure and windows. Use a paler wash to cover them and force them together.

6 Use a dry brush to overlay color, while the dark linework underneath is still wet.

PRACTICAL TIP
With a complicated structure that cannot be quickly or easily replicated, show the most obvious features with dark ink and cover the detail with a strong wash.

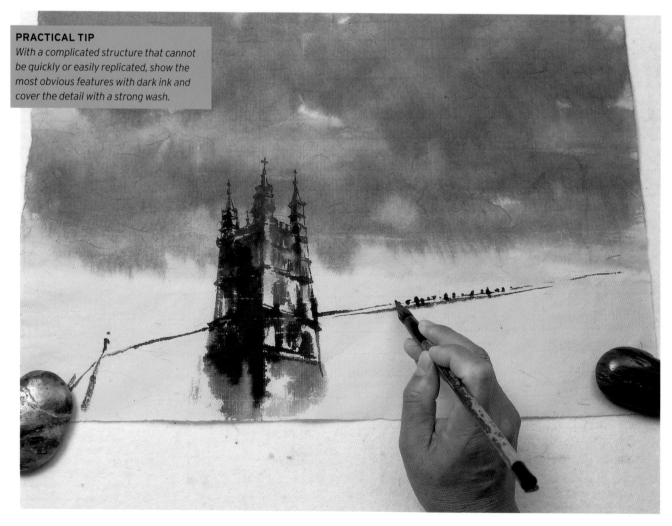

7 When the central structure is complete, paint in the roofline across the paper.

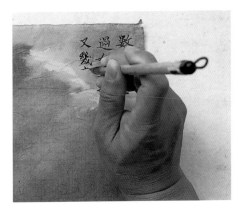

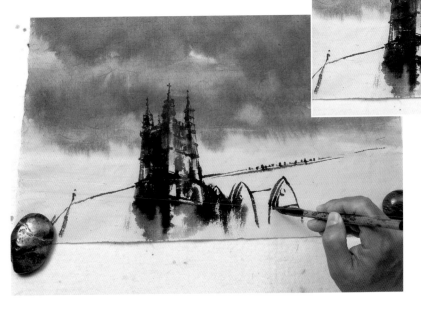

8 Add in the basic Gothic features before filling in with a soft brush to hide the unpainted detail.

9 Write calligraphy across the clouds, either poetry, as here, or simply a description or title.

ALTERNATIVE
Use the same method to paint cityscapes under threatening skies. Create the powerful sky by making a strong contrast between the sharp lines of the buildings and the looser shape and tone of the clouds.

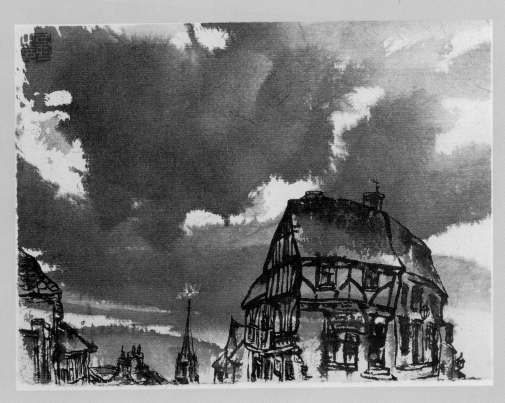

PEOPLE AND PLACES:
Village Drawing

Drawing a line sketch in pen without color or shadow is an excellent way of recording form, but it can leave a scene feeling slightly unreal. A good way of adding a personal touch, that can remind you of the reasons you wanted to sketch the scene in the first place, is to add a spot of color into an otherwise monochrome drawing. Here I needed only to add the brightness of the fruit and leaves to take me straight to that hot Mediterranean day in Portugal, with orange groves bursting with ripe fruit.

> "The art of painting and calligraphy should always be created by *chi*."

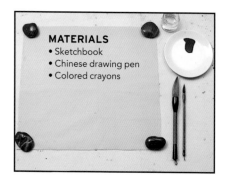

MATERIALS
• Sketchbook
• Chinese drawing pen
• Colored crayons

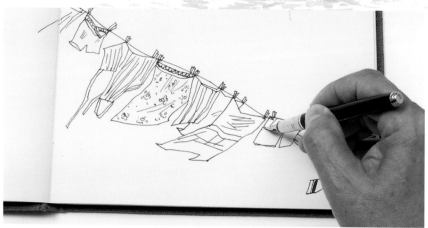

1 Using a pen, draw the outline of the scene, starting with the feature unbroken by anything else—here it is the washing line.

PRACTIAL TIP

If we compare a sketch with a photograph we can see that the reason the sketch usually feels more lively is because not everything in the scene has been included. We can emphasize the most interesting parts and subdue others, using our own visual language to describe our impression.

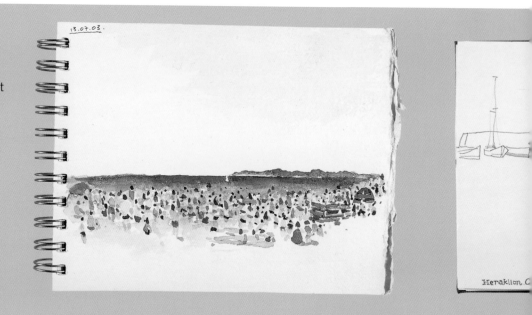

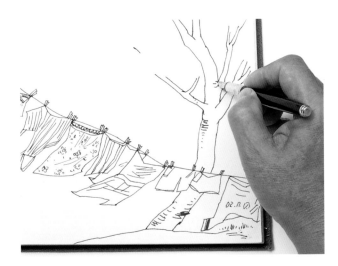

2 Draw in the basic skeleton of the tree to act as the structure for the rest of the sketch.

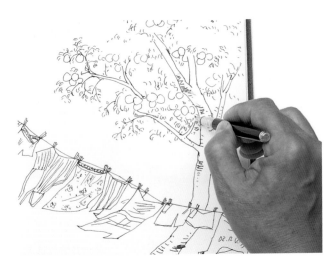

3 Add all the leaves and fruit of the orange tree, building up the form of the healthy tree.

4 Highlight a single spot with color using orange and green crayons.

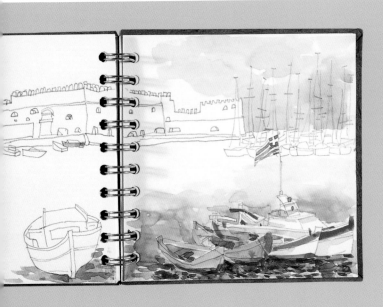

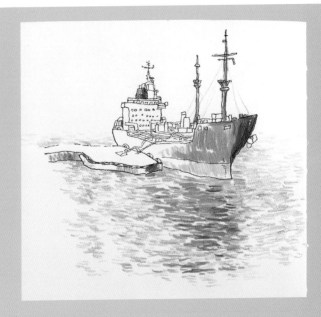

PEOPLE AND PLACES:

River Scene

The banks of the Mekong River in Vietnam are lined with the endless blocks of trees and foliage. From time to time the monotony is broken by the appearance of high coconut trees or little riverside villages. The whole scene is completed by the fishing boats slowly floating toward their home and the light sparkling on the water.

Even in the early morning the sun is hot. Mekong River, Vietnam.

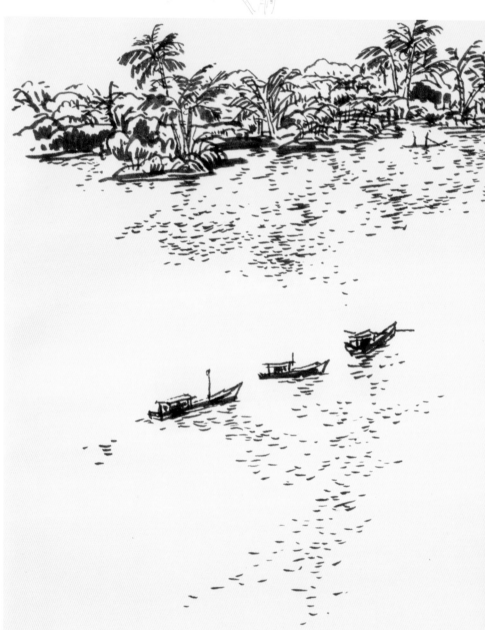

MATERIALS
• Sketchbook
• Chinese fountain brush

1 Pick out a single point and start here–in this case a palm tree. When sketching a busy scene like this forest try to give every stroke specific form.

2 Build up the vegetation around the first tree, layering the plants to give density to the scene.

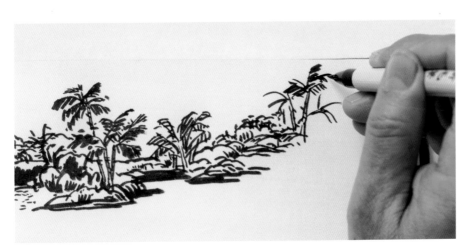

3 Differentiate between the various elements of the forest where possible. Include different species and types of vegetation when building up the riverbank.

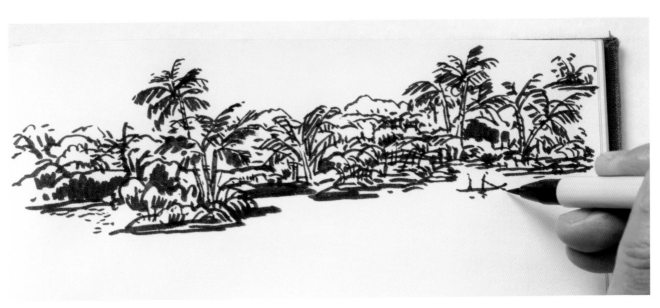

4 Quickly build up the thick jungle, but ensure that you sketch in all the other elements of the shoreline. Here this includes a small beach, a village, and a single canoe.

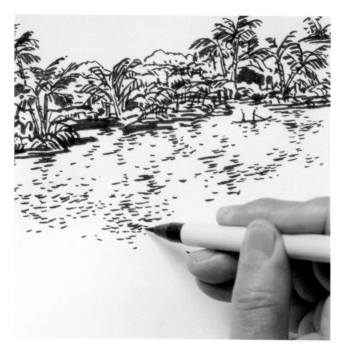

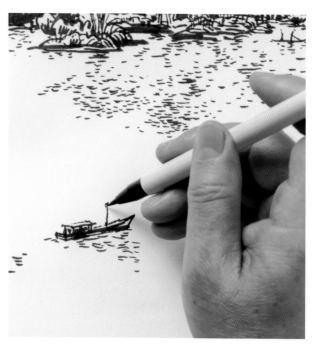

5 Only when the riverbank is complete, move to the second element of the sketch, the river. Use little flicks of the fountain brush to indicate the moving water and reflections.

6 The final element of the sketch, the boats, links you with the scene beyond. Take care to match the scale of the boats with the riverbank beyond.

ALTERNATIVES

Rivers and oceans are vibrant echoes of a country. Scenes can either be quiet and timeless, like the stilted riverside village, or incorporate the modern. The large cargo ship passing Buddhist temples along palm-lined shores combines the old and new in a quickly worked fountain-brush sketch. The vessel at anchor is another impression of modern life imposing on age-old traditions.

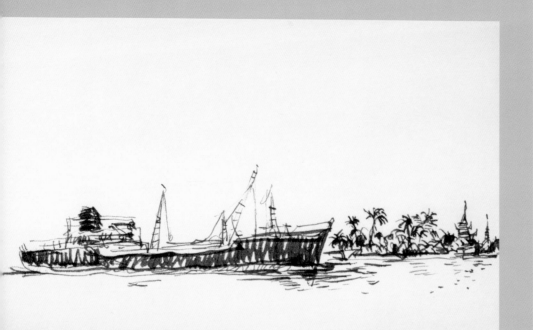

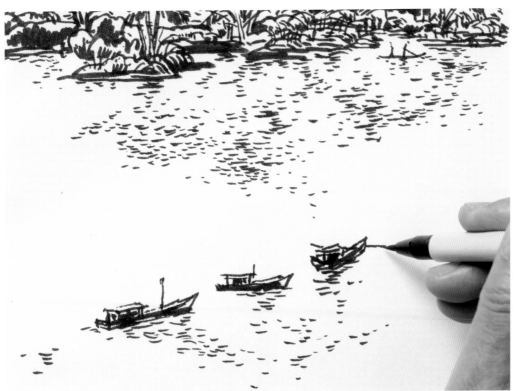

7 If you weren't able to sketch the boats immediately, place them now where they fit most naturally into the picture and are best framed by their surroundings.

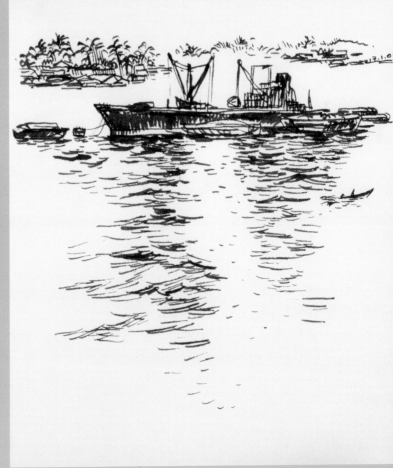

PEOPLE AND PLACES:
Against the Light on the Sea

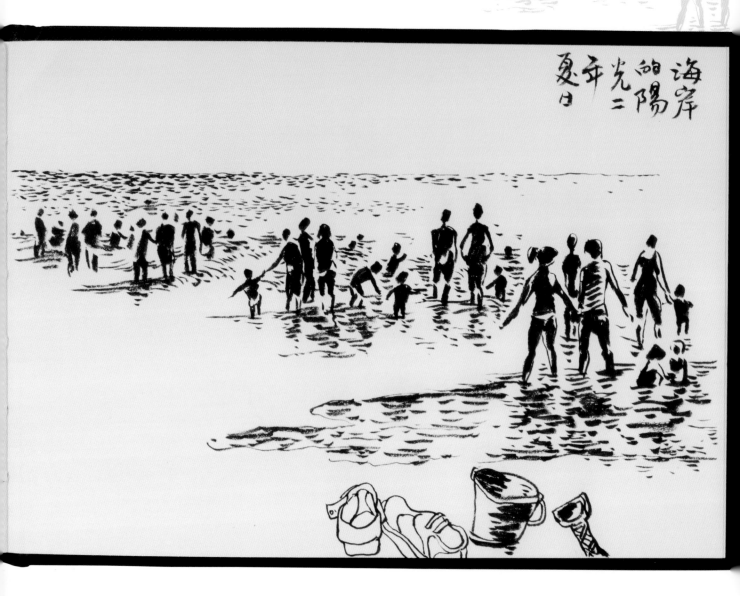

海岸 的陽 光二 弄 夏日

Sitting on the beach while on holiday can be an ideal time to sketch. The glare of bright sun on water and sand offers an interesting view to the sketcher. Detail is often washed away, leaving shape and movement as the only indications of what is on view. The silhouettes and reflections in the waves can be vividly—and easily—captured with a dark fountain brush.

MATERIALS
• Sketchbook
• Chinese fountain brush

1 Start by drawing the nearest figure, in silhouette from the head downward, making an outline of the woman's body.

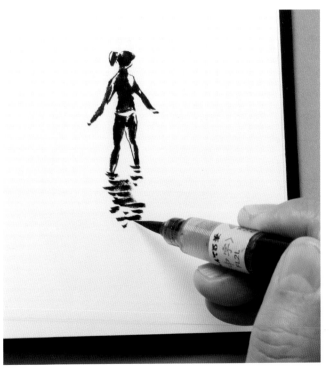

2 Fill in with ink, leaving the paper blank to indicate her swimsuit. Immediately draw in her reflection in the water.

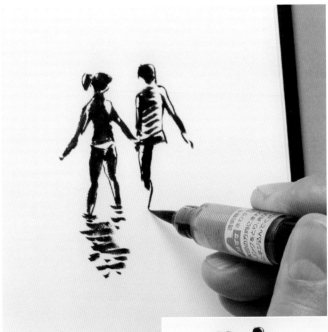

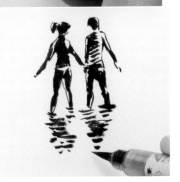

3 Follow by adding her companion. Use the tip to make fine outlines and a fuller stroke to fill in the figure and mark its reflection.

> "Read 10,000 books and travel 10,000 miles, and your brush will be full of the spirit of nature."

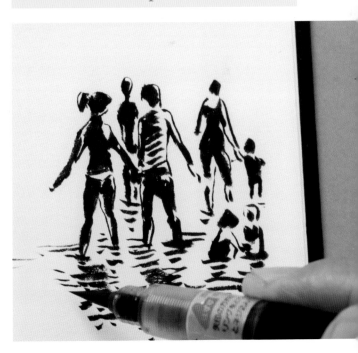

4 Finish the closest group by including some figures behind and two children playing in the water. This could stand on its own as an image, or be the focus of a larger view.

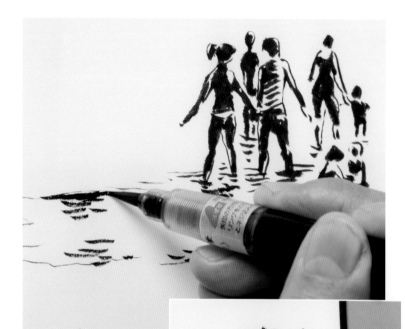

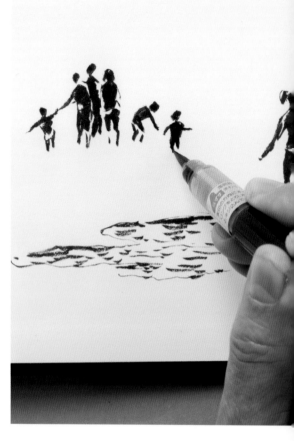

5 To position the group in relation to the artist, mark the water lying on the sand, hatching horizontal dots to give reflection.

6 Start the second group. To ensure perspective, place them above the first group on the page. Make them smaller, and show less detail on the figures.

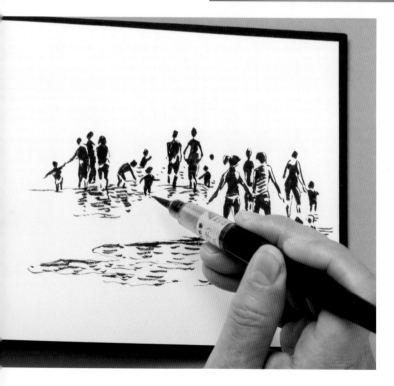

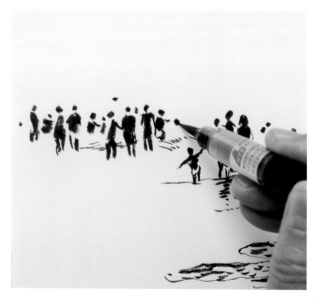

7 Adding more figures to the group and their reflections fills it out and confirms its relationship to the first group.

8 The beach is full of people, so include figures far into the distance. As before, the harsh sun removes all detail, leaving just shapes against light. This group is even less detailed than before, showing just a series of bodies and heads.

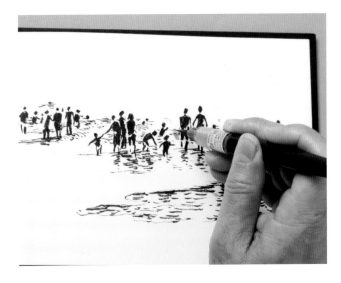 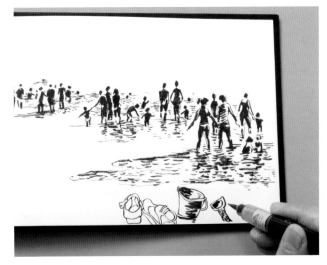

9 The sea around the figures is the device that joins the groups together. Add reflections and wavelets between the figures.

10 Adding motifs into the picture can further describe the sketcher's relationship with the scene. The shoes and beach toys indicate a family holiday.

11 Mark the horizon with a series of horizontal dots. Never use solid lines—there is movement, even if you have to look for it.

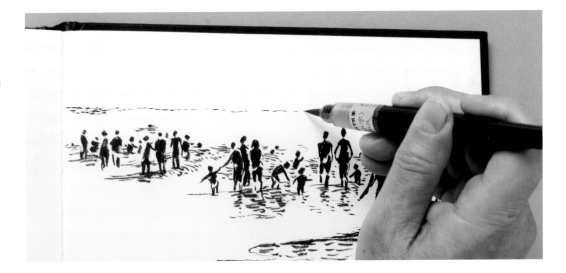

12 Complete the sketch by adding an impression of the sea. Nothing more than an indication is required.

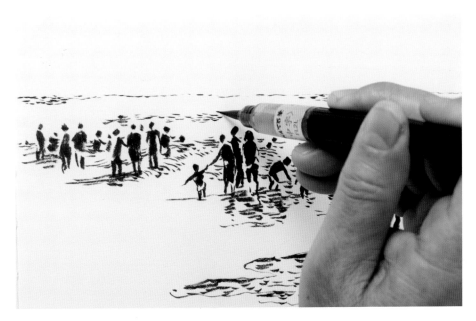

PEOPLE AND PLACES:
Drawing from Life in Ink

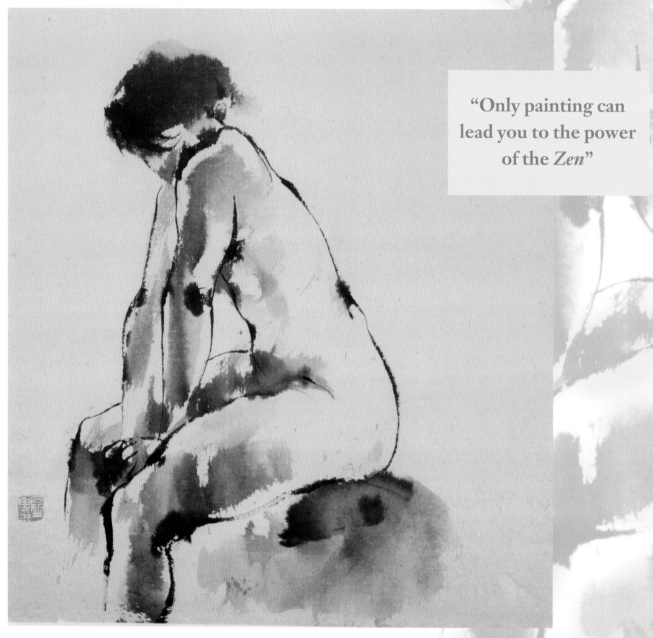

> "Only painting can
> lead you to the power
> of the *Zen*"

The human form has always been one of the most
appreciated subjects in art. Sketching with a Chinese
brush and ink allows us to show the form and character
of the body. Discover the *Tao* of a figure by contrasting
the soft, pale ink of the figure's form with the strong,
dark edges that show its structure.

MATERIALS
- Paper
- Felt
- Large, soft brush
- Small, stiff brush
- Chinese ink
- Seal and seal ink

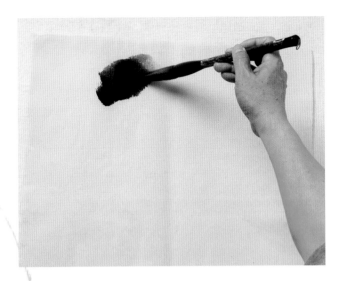

1 Take the large brush and mix a strong, dark ink. Start at the top of the figure with two large strokes for her hair.

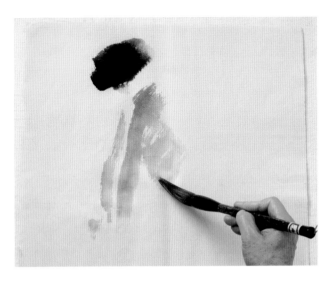

2 Mix a much lighter, more watery ink and use the same brush to show the main form of the body and arm. Use single strokes for each element, never repeating or covering a stroke.

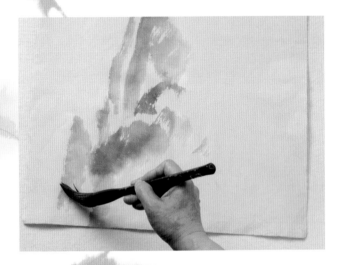

3 Again, use light strokes to give the form of the thighs and legs with a pale wash.

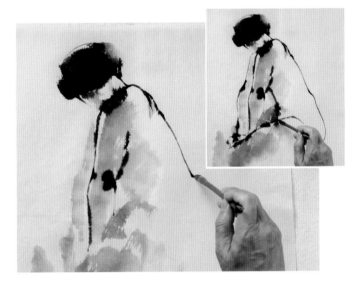

4 Change to a small, stiff brush to draw the outline of the body's structure. Start with the head and neck, continuing down the near arm and back. Make extra dot strokes to show the shoulder and elbow. Continue down the body and legs.

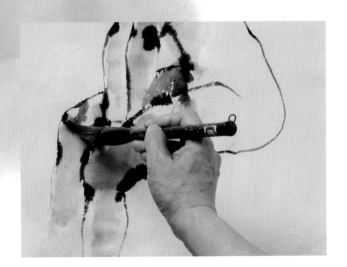

5 Use the big brush to add definition to joints by washing over them with color.

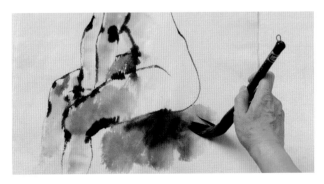

6 To form the seat, apply dark ink with the small brush and wash the color around with the larger brush. When dry add your signature or seal.

PEOPLE AND PLACES:
Drawing from Life in Pencil and Wash

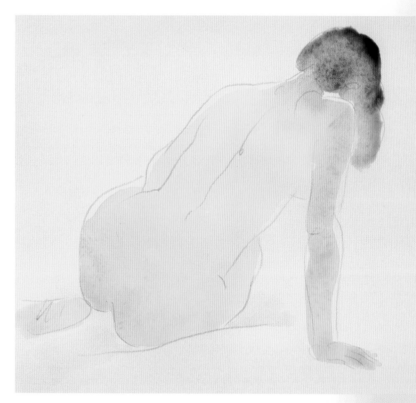

MATERIALS
- Sketchbook
- Soft 2B pencil
- Large, soft brush
- Watercolor paints:
 burnt sienna and indigo

> *"Sketching is the foundation of every kind of art."*

Sketching a figure in pencil and wash is one of the most fundamental exercises when attempting to reach the *Tao* through sketching. As one of nature's basic building blocks, it is full of *chi* energy—catch its rhythm and you can begin to catch the *Tao*. Let the pencil show the structure and shape of the body and use the color to indicate no more than the tone.

1 Starting at the top, use a soft 2B pencil to draw the basic outline of the head and arms, using the minimum amount of strokes to progress down the figure.

2 Show the shape of the body in just three lines, then outline the bottom, legs, and surface.

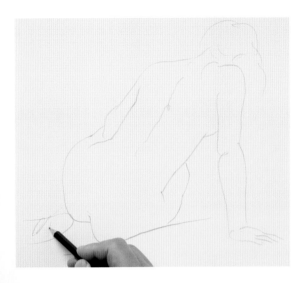

3 Finish the pencil lines by adding the sole of the foot tucked underneath the body.

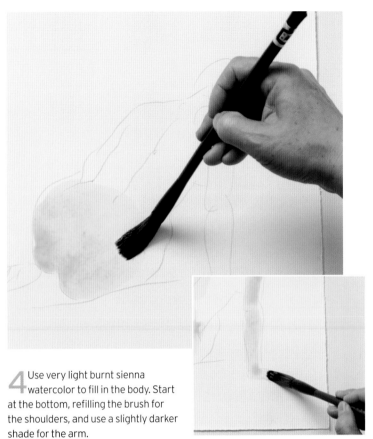

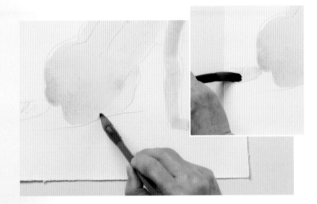

4 Use very light burnt sienna watercolor to fill in the body. Start at the bottom, refilling the brush for the shoulders, and use a slightly darker shade for the arm.

5 Fill in color up to the pencil marks, but try not to go over color you have already painted—the whole body should be painted in three strokes. Finish by adding color to the sole of the foot.

PRACTICAL TIP
With a very short posing time you need to practice sketching quickly. You need to be quick and accurate, while retaining a feeling of life in the figure, even when it is made up from such a small number of strokes.

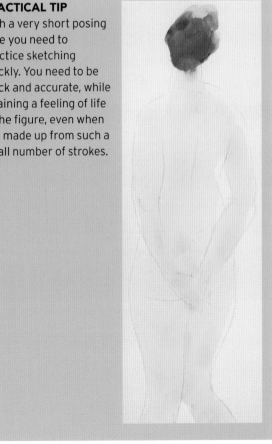

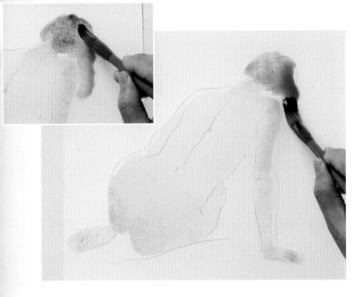

6 Darken the wash by adding indigo and paint the hair, highlighting it with a slightly darker shade before it dries.

PROJECTS: FLOWERS AND PLANTS

Flowers, grass, and trees are all necessary and vital parts of our life, and painting them has been highly respected throughout the history of Chinese art. This is because Chinese artists not only paint the natural form, but also give it a human feeling and philosophy. The combination of nature and man in one gives each plant a symbolic value—such as the strength of pine, the clarity of lotus, the nobility of bamboo, and the elegance of the orchid. When sketching we should be concerned with both the shape and spirit of the plant, expressing the spirit through what we paint. You need to quickly and accurately capture each plant's individual form. Work towards a deeper understanding of each plant's shape, take into account its symbolism, and take care to choose suitable materials to express these characteristics.

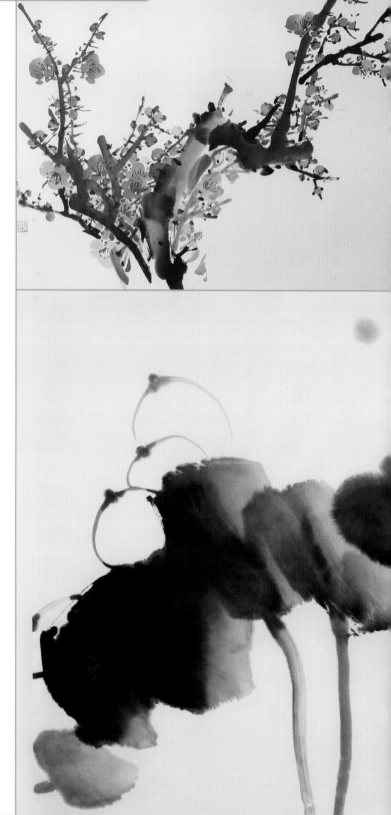

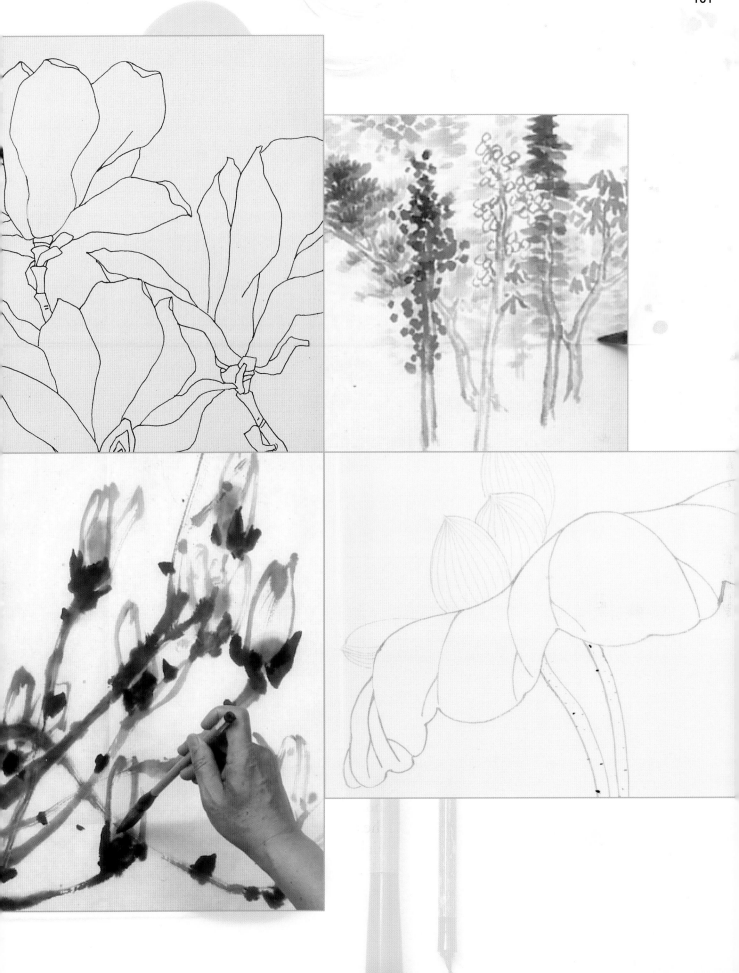

FLOWERS AND PLANTS:
Pen-drawn Magnolia

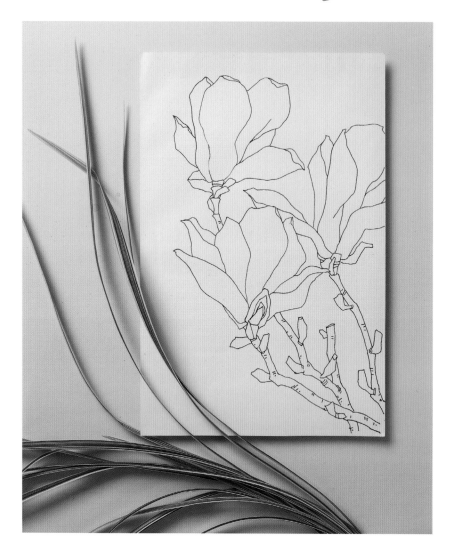

MATERIALS
• Sketchbook
• Fine-line black pen

"When we know what something looks like we should also understand why it is like that."

With a contradiction typical of the *Tao*, the sketcher knows that to be able to draw a flower spontaneously, he first needs to know the rules. Start by studying a range of blooms, particularly when they first blossom in spring, and begin with a single-line study of the plant you like. Use pencil or pen, ignoring color and shadow, and use only line to discover its structure—the way the branches entwine around each other and the position from which each petal grows. Work petal by petal, branch by branch and study carefully which branches cover others so that you can build up the structure of the living plant.

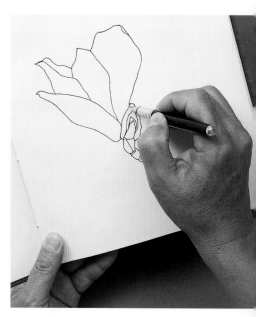

1 Study the plant you want to draw and find the flower and branch closest to you. Always start with this, drawing the outline of the most visible petal first.

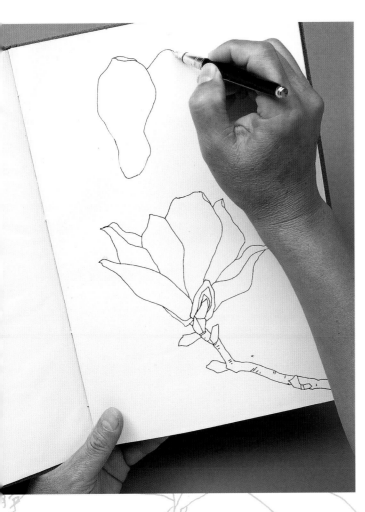

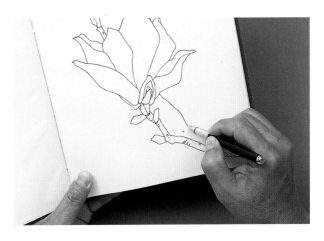

3 Draw the calyx and stem in one movement.

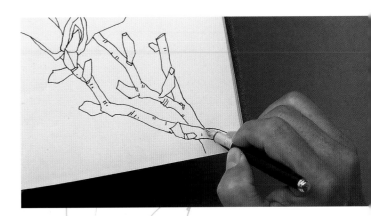

2 Build up the rest of the flower around the petal.

4 Find the next flower and position it by drawing the most prominent petal first.

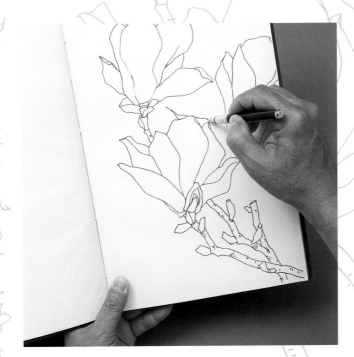

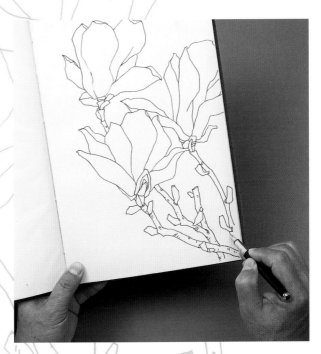

5 Draw the stem, taking care to make the points where it lies behind the first flower join together naturally.

6 Draw the third flower and remaining stems in order so that you do not have to break any lines to leave gaps for other branches.

FLOWERS AND PLANTS:
Painted Magnolia

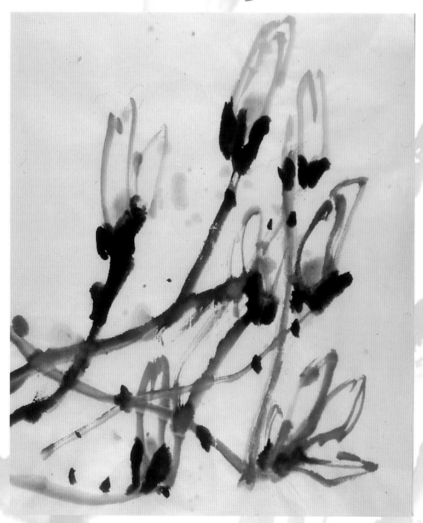

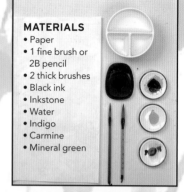

MATERIALS
- Paper
- 1 fine brush or 2B pencil
- 2 thick brushes
- Black ink
- Inkstone
- Water
- Indigo
- Carmine
- Mineral green

PRACTICAL TIP
Even a quick pencil sketch of your subject has many uses; you will capture the shading, structure, and movement prior to brushwork.

> "There is always a poem in a painting, and there is always a picture in a poem."

Sketching a small item can be a great way to remember a single moment or mood. Once you have chosen an item that sums up the mood or moment—a flower is often a perfect example—use the techniques on pages 26–28, these allow it to be captured as quickly and accurately as possible. Start with a sketch of leaves, stalks, and blooms, so you have a clear pattern of the flower structure; once you have the layout of your work clear in your mind, move onto the brushwork on a new sheet of paper to add self-expression. Use the brushstrokes and structure to bring out the feelings that bloom in you when you catch sight of a spring flower opening toward the sky.

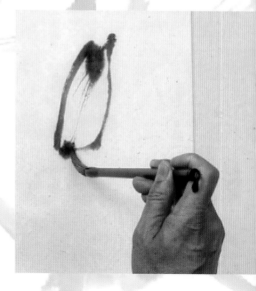

1 Concentrate on the position of the first bud. With simple, quick strokes, use a pale and wet, light ink to show the first bud.

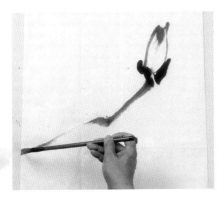

2 Mix a darker shade of ink for the three calyxes at the base of the bud and its stem. Again, think about where to place the brush and work in a single movement.

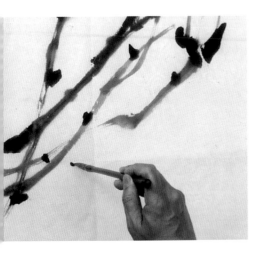

3 Return to the lighter shade of ink to sketch the second bud. Then add more branches in darker ink. Always paint each element in order—remixing the paint at each stage.

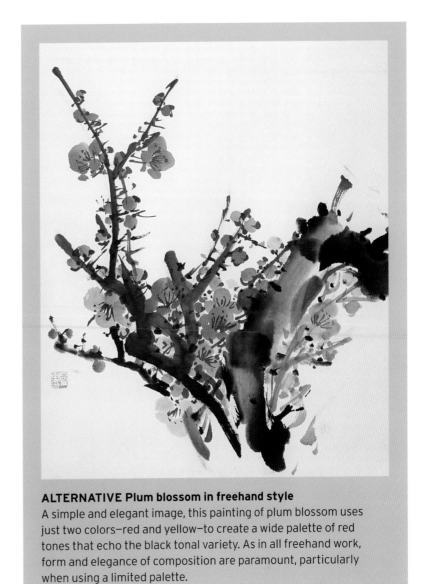

ALTERNATIVE Plum blossom in freehand style
A simple and elegant image, this painting of plum blossom uses just two colors—red and yellow—to create a wide palette of red tones that echo the black tonal variety. As in all freehand work, form and elegance of composition are paramount, particularly when using a limited palette.

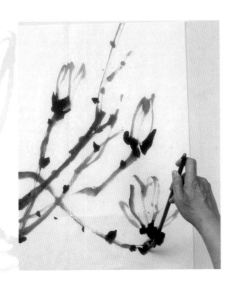

4 Finish with the open flower. Again, use the basic stroke to give the outline of the petals before adding the calyxes and stalk.

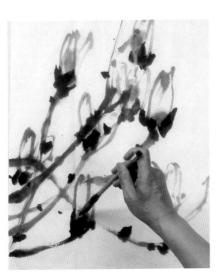

5 Add color to the base of the flowers with a light wash of indigo and carmine inks, mixed to a deep purple shade.

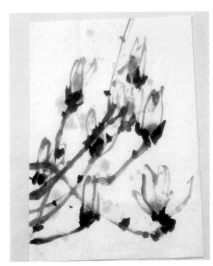

6 Sprinkle mineral green ink across the whole picture to give a speckled effect—reminiscent of a meadow or woodland.

FLOWERS AND PLANTS:
Lotus Plant in Ink

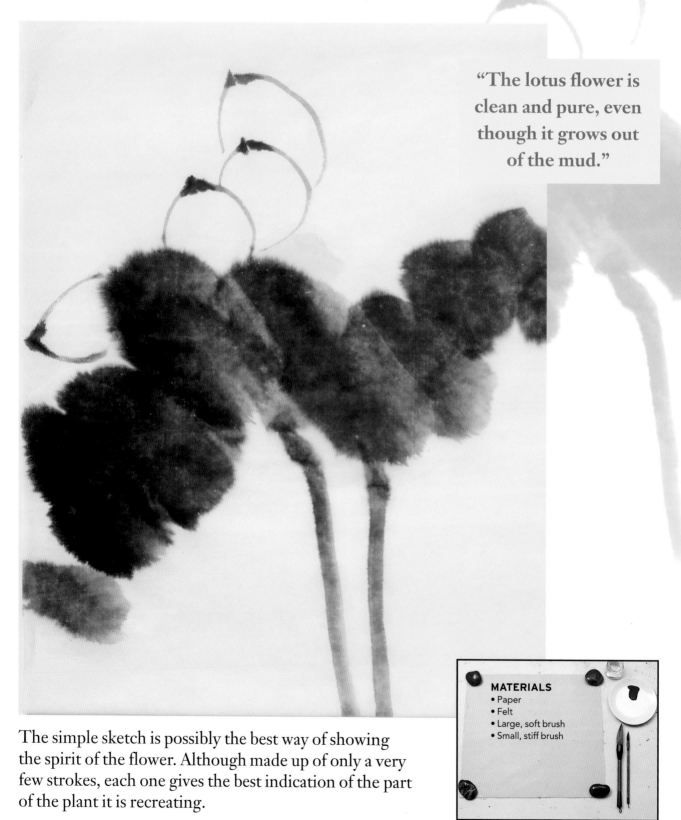

> "The lotus flower is clean and pure, even though it grows out of the mud."

The simple sketch is possibly the best way of showing the spirit of the flower. Although made up of only a very few strokes, each one gives the best indication of the part of the plant it is recreating.

MATERIALS
- Paper
- Felt
- Large, soft brush
- Small, stiff brush

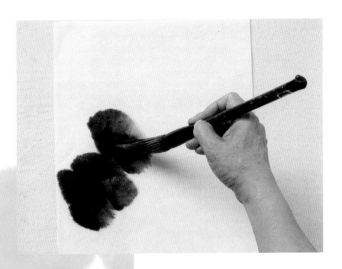

1 Use a big brush with dark ink to make three large, vertical dot strokes. Each one represents a small part of an entire leaf.

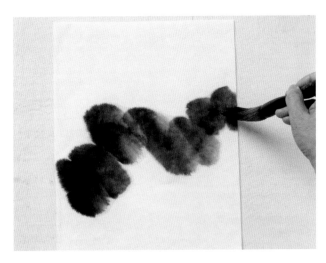

2 Make four more dot strokes across the paper to show the curved edge of the leaf.

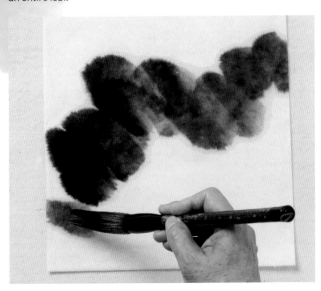

3 Add an extra dot in slightly paler ink if necessary to show the furthest edge of the leaf.

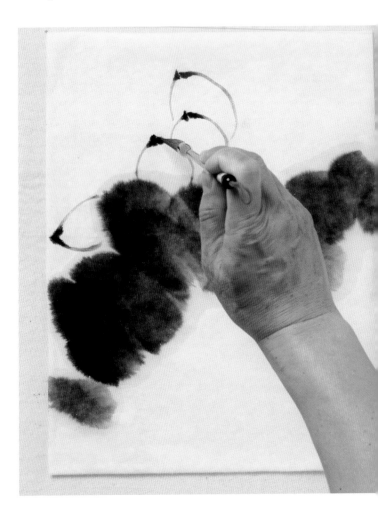

4 Use a small, stiff brush to sketch the petals. Each should have a dark patch on its tip to make the flower feel brighter.

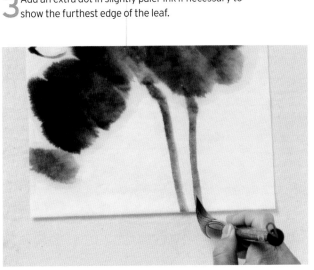

5 Use the thicker brush and drier ink to paint the stalks.

FLOWERS AND PLANTS:
Outline Drawing of Lotus

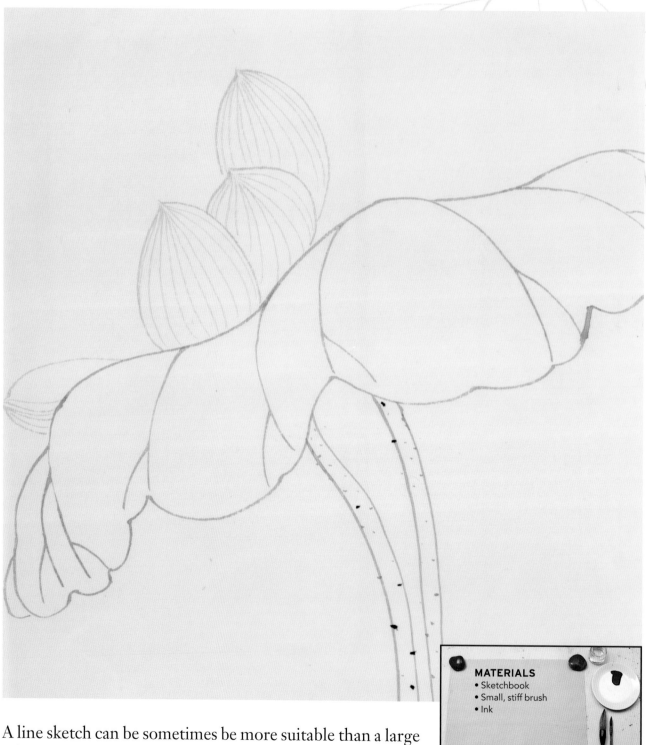

MATERIALS
• Sketchbook
• Small, stiff brush
• Ink

A line sketch can be sometimes be more suitable than a large ink work for recording the structure of the plant—in this case the same lotus as before. Practice drawing various types of plant to catch the subtle differences between species.

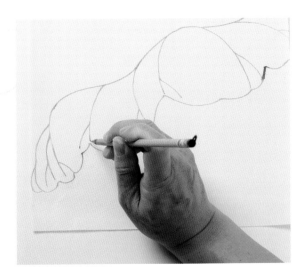

1 Begin by drawing the outline of the big leaf that dominates the plant. Ensure you catch its curling edge and then add the network of divisions that run through the leaf.

"If you can get the natural world into your heart, the art will already be there."

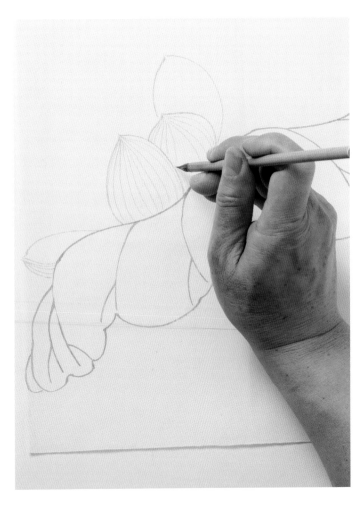

2 Draw in the petals in lighter ink, giving each one a solid outline. Add veins showing as the light shines through the translucent petal.

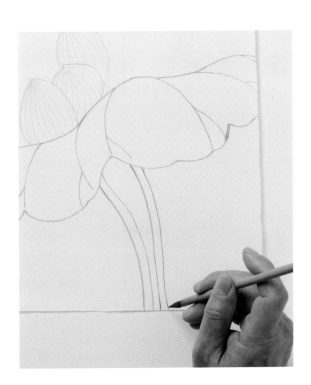

3 Use a darker ink to draw in the stems. Check that they are in line with the petals above the leaf.

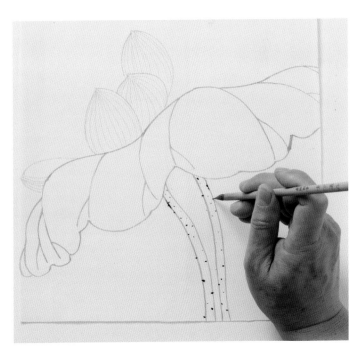

4 Delicately add spots onto the stems, letting them contrast with the lines in the petals.

FLOWERS AND PLANTS:
Trees

This painting shows you how to create and practice the many different leaf strokes that emphasize the range of trees you will find in your sketching. The techniques are easy to master, and you will soon learn how to create all sorts of broad-leafed and pine trees, as well as how to combine them into a forest, or a group of single trees.

MATERIALS
- Paper
- Thin brush
- Medium, blunt brush
- Black ink
- Ink stone

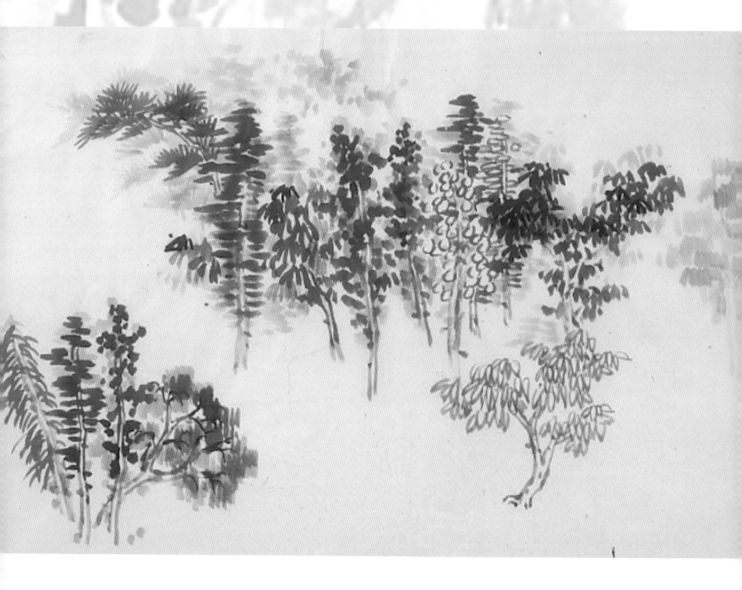

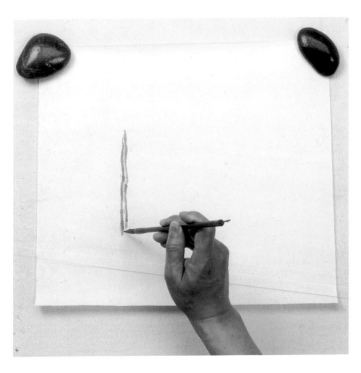

1 With dry, light ink paint the first tree trunk, using the thin brush in two, parallel strokes (see pp. 26-28), overlaid with paler ink.

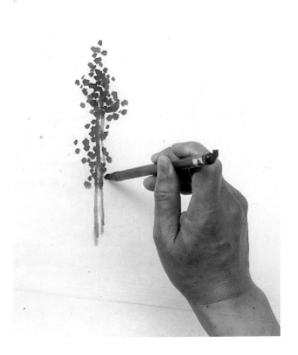

2 Paint dark leaves around the trunk with the blunt brush, to give an impression of a poplar tree. Use a "pepper dot" stroke to dab ink onto the page in simple dots.

> **"The painter must live between heaven and earth: Study the *Tao*, then develop the *chi*, then travel among mountains and rivers."**

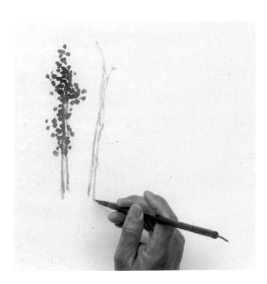

3 Add a second trunk in the same way as the first. As you work keep the ink paler for the trunk than for the leaves.

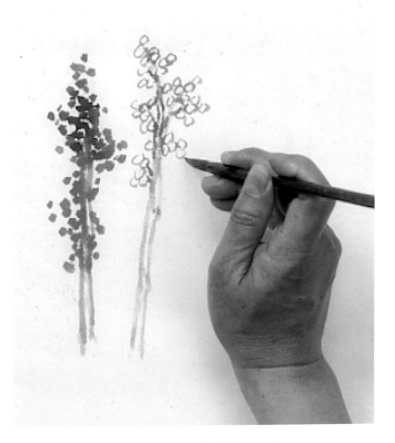

4 This time use a "circle dot" stroke, also signifying a poplar–making small rounded marks in mid-dark ink with the blunt brush. Let them overlap slightly with the first tree.

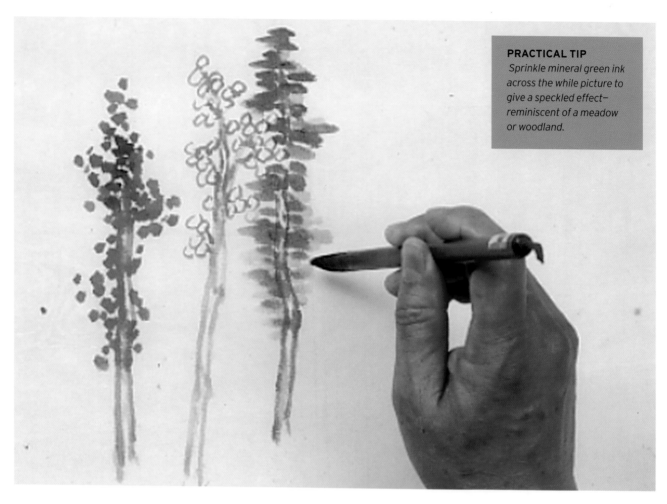

> **PRACTICAL TIP**
> *Sprinkle mineral green ink
> across the while picture to
> give a speckled effect–
> reminiscent of a meadow
> or woodland.*

5 The third tree, a fir, is shown with a horizontal dot. Let
each stroke become a line, tightly packed to its
neighbor, again overlapping with the other trees.

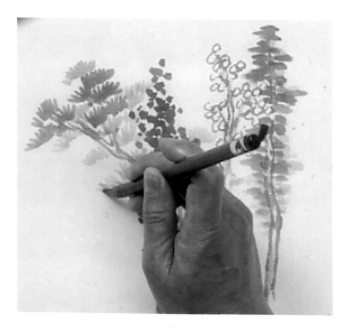

6 The fourth type of dot, the upward dot, is used for pine trees. Paint
the dots in a fan formation.

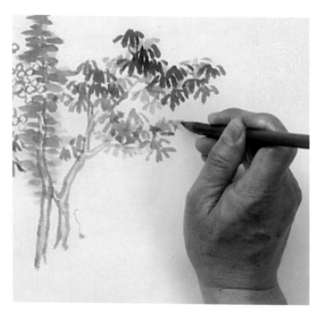

7 The final dot, for the horse chestnut or maple, is a variation of
the long dot. Group shorter vertical dots together in formations
that resemble hands.

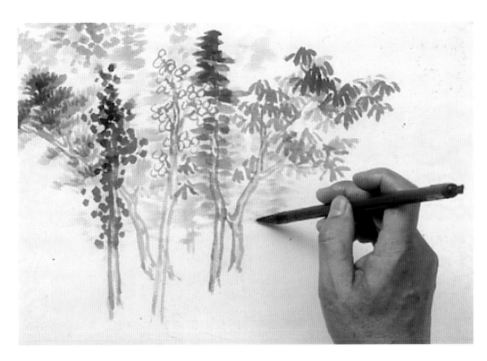

8 Using the fine brush, give the trees depth by combining the leaf types further and adding more distant leaves. Do not make any markings beneath the trunk bases; the blank area represents water.

TREE VARIETIES
Chinese art uses trees as symbols of life—the pine signifies endurance through the cold of winter, a bamboo strength and flexibility through adversity, and a maple tranquility.

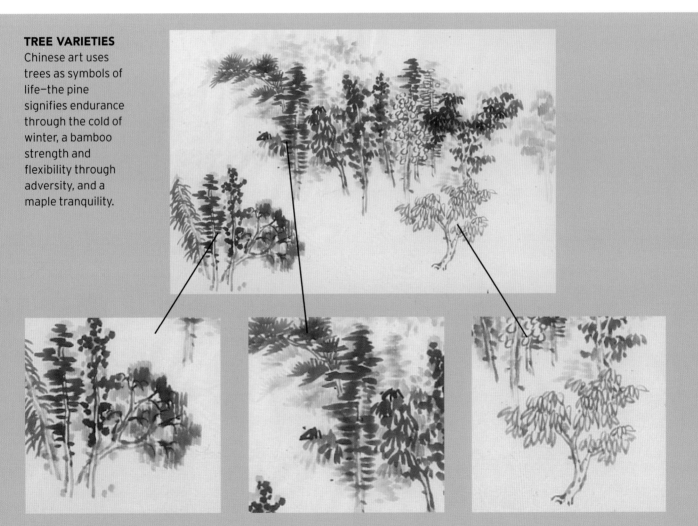

VARIED PINE
Use light and dark inks to represent different needle colors.

LONE PINE
For short-leaved pine use the horizontal dot stroke.

HORSE CHESTNUT OR MAPLE
Use the circle dot stroke to create the leaves of these trees.

PRACTICAL SKETCHING TIPS

Many people are interested in learning to sketch and many have expressed the desire to do it well, but they always face a number of problems. Often, though, they can be held back by something simple—like not preparing the necessary materials, or feeling embarrassed to draw in a public place, or not knowing where to start or how to tackle an inspiring scene.

The aim of this section is to give you some practical advice to solve these problems.

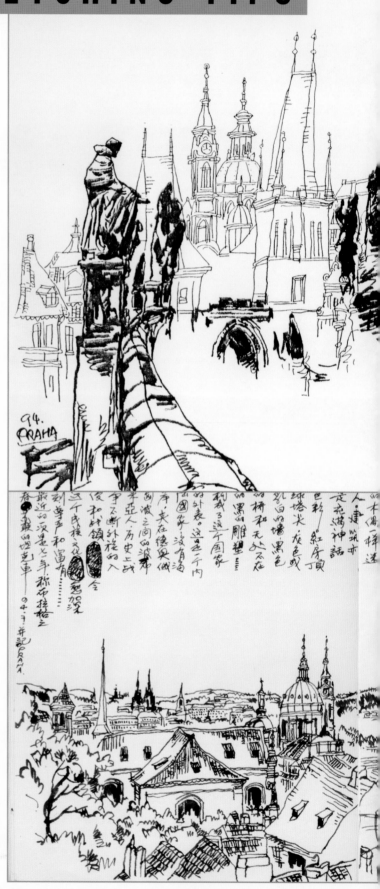

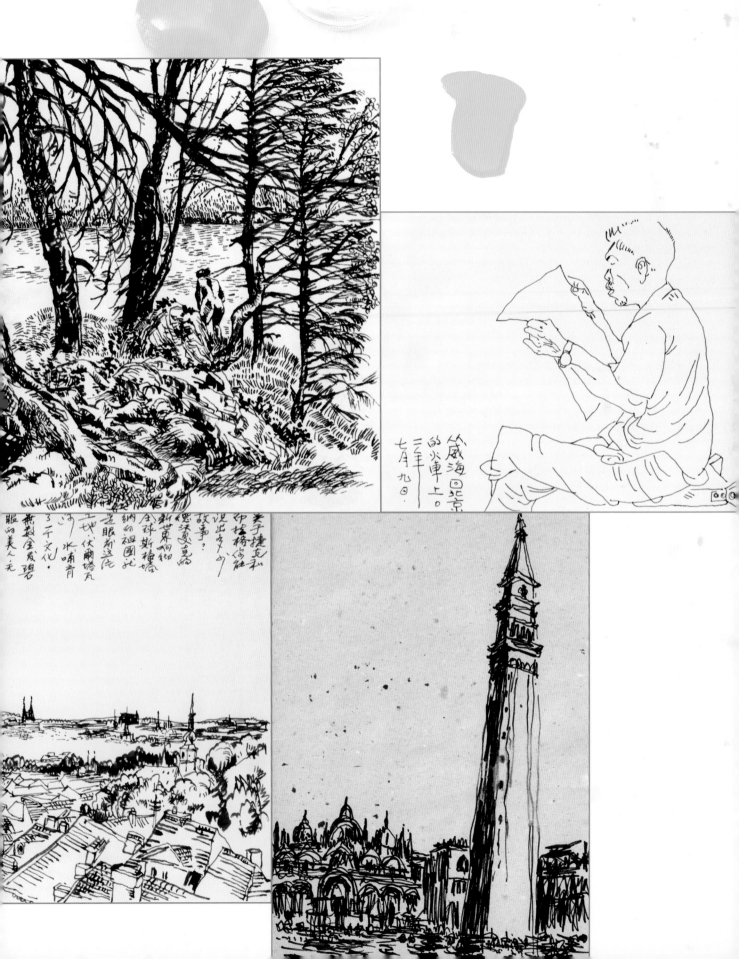

Never Give Up

Accept whatever situation you find yourself in. Enjoy your sketching and never give up—if you persist you are sure to gain something beyond your expectations.

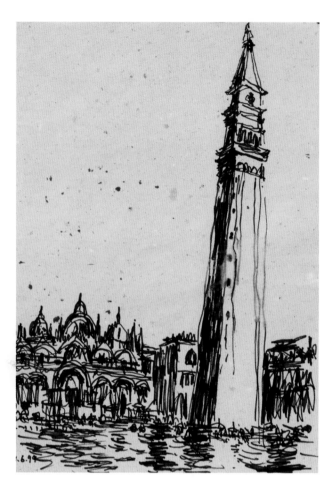

While in Venice I was sketching in St Mark's Square when it suddenly started raining. I told myself not to give up and I particularly enjoyed sketching the reflections being cast in the rain glistening on the tiled floor. Although I found some shelter, a small amount of rain still fell on my paper. It was only afterward that I realized the smudged effect was advantageous for describing the feeling of rain.

This view was a lucky accident: When I was forced to retreat beneath cover I discovered this fascinating composition.

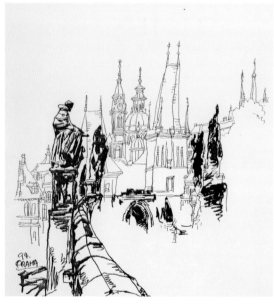

While I was drawing the foreground of a cityscape my ink pen ran dry. My only other pen was a fine-line black marker that made a completely different sort of mark. I decided to continue and to my surprise found the distance was described more effectively: The bolder ink marks come forward, while the finer lines tend to recede.

Arrange Your Composition With Care

Whether you are painting a complicated picture or a very simple sketch, you should consider the composition from the very beginning. Do not begin to draw without thinking.

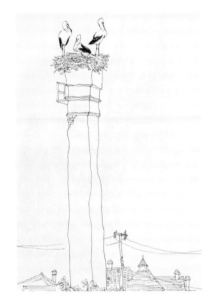

There was something of a fairytale charm to these storks, standing precariously on the high, thin chimney. The birds had to remain the focal point, so I started high up the page and deliberately placed the roofs and telegraph poles at the bottom.

It is important to catch the contrast between the elements in a view. By exploring stillness and movement, bigness and smallness, darkness and light, the heavy and the light, you can immediately give a sketch an interesting spirit. When I was sketching the magnificent Karnak temple, the tourists, going in and out like tiny ants, emphasized the building's size.

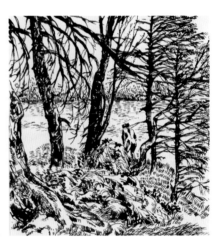

Figures in pictures can easily become focal points. In this sketch I wanted the girl to be the point of emphasis, but I also wanted to get involved with the surrounding trees. The variation of curved and straight lines that I was witnessing seemed like a piece of music. I tried to reflect this feeling with my dots and lines, both long and short, and big and small.

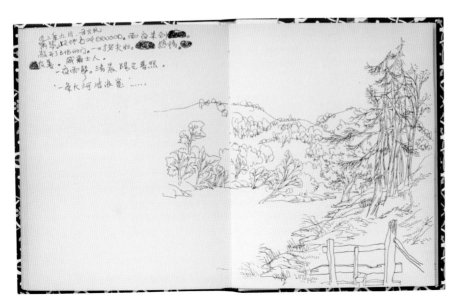

Always consider the space and density of a picture. If you draw an area of heavy detail, leave a big empty space for your imagination. In Chinese art these are called unbalanced compositions. You can open your sketchbook and draw on both pages to make a good landscape format, but try not to use the reverse of another picture.

Expression of Spirit

When we are sketching people, whomever they are, the most important thing is to catch their soul rather than simply form their shape. This will come through your observation and understanding of people, as well as being able to catch the moment that best reveals a person's *chi*.

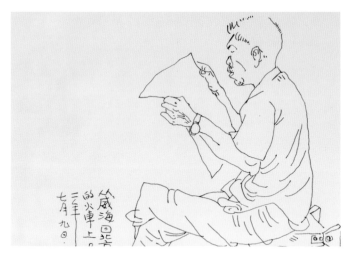

This is an ordinary passenger and he looks very modest and is concentrating while he reads the paper on his long journey. When I am doing the line drawing, I let every line show what I feel about this man: ordinary, honest, concentrating, and sincere. Those feelings come out of his hand as well as his facial expression.

This English lady is sitting in front of the television after dinner. We can even guess that she is watching a serious program, all from her sitting position and expression. The little details on the chair show the environment.

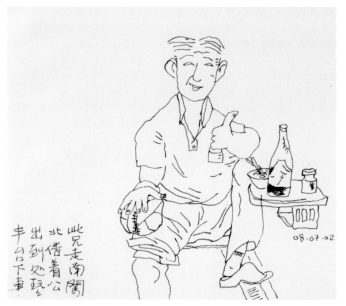

This man was boasting about how clever he was—traveling on the train and eating at his company's expense. He was friendly and outgoing, and all his characteristics are shown in his hand position, the way he is sitting, and his hairstyle. His rolled-up trousers, slipped-on shoes and the bottle on the table confirm the impression.

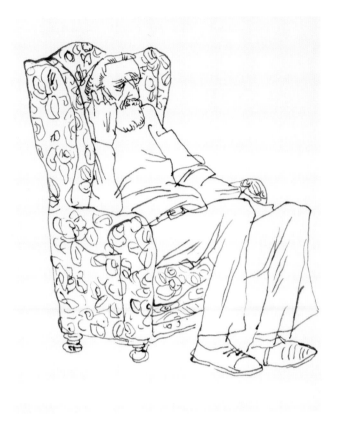

This man is having a rest in an armchair. This type of ordinary, everyday scene shows the sitter's culture and gives atmosphere to his life.

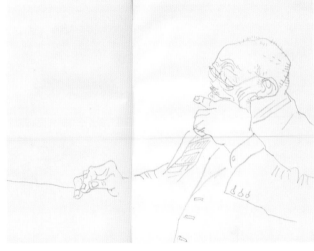

This priest was sitting in front of me in the airport waiting room reading the Bible with concentration. His strong, powerful hands show his personality and his mood.

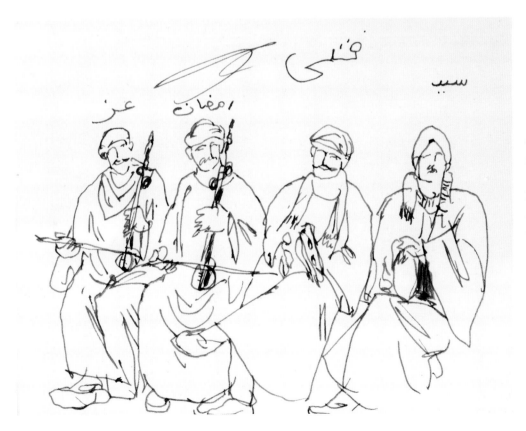

The sharp but stimulating sounds of the band's instruments resonated around the hotel courtyard. The more I studied the group the more visually interesting they became: Their slightly contrasting positions, the ebb and flow of their gently swaying bodies, and their bushy eyebrows all caught my attention. I wanted to capture their charm and enthusiasm. As an afterthought I asked them to sign their names above their portraits, lending even more of an Arabic flavor to the sketch.

Structure

Structure is the essence of everything. Without light, shadow, or any other effect, the line becomes the most basic language with which to capture a scene, requiring only simple, but accurate, rendering.

Drawing a beautiful lamppost like this will improve your drawing skill and can also be useful as a study for future use. Look carefully and draw accurately, studying the curves and lengths of lines, the broad and narrow shapes, the proportion, and how each part joins together. In this type of study, the key is to draw slowly, avoiding careless lines.

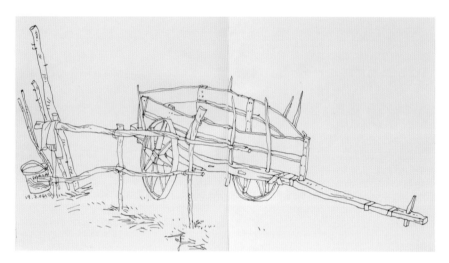

In a mountain village a boatlike cart I had never seen before captured my curiosity. Even now I cannot work out how the bull pulls it. To have a record of it, I drew it honestly, showing exactly how it was made, all the time remembering one piece of sketching advice: "Draw what you see, not what you know."

Everything in this scene—the wooden structure, the bamboo pole, the bird food, and the plant—has been positioned and included naturally over time. The interest is in the beauty of the items so we should catch as much detail as possible.

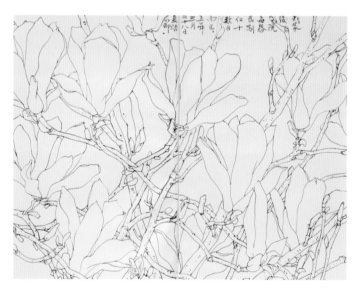

Using line alone to show a three-dimensional structure is an essential part of Chinese painting. This requires a deep understanding of an object's structure and depth as well as drawing technique. The technique comes out of understanding which lines cover which other ones, which lines join other lines, and which lines are covered by others so that a subject is given structure and depth, rather than flatness.

How to Catch the Light

Often when looking at the natural world it is the light that catches our attention. We should be able to use simple techniques and materials to catch the feeling of the moment in order to further develop the picture.

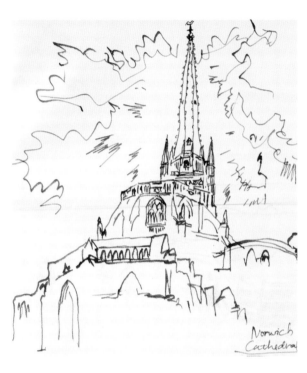

The sunlight shining directly behind this magnificent building shows its glory and dignity. It is important to use the contrasts between the shape and the light properly: One is dark, the other bright, one is still, the other moving, and one is representational, the other abstract.

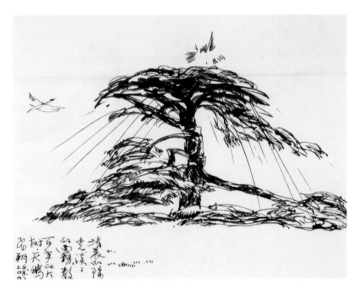

The morning sun has just risen above the huge cedar tree, sending the light through the mist and the tree's branches, and a swan is passing by. The whole shape of the image emphasizes the rising sun. I quickly caught the moment and I have never forgotten that view.

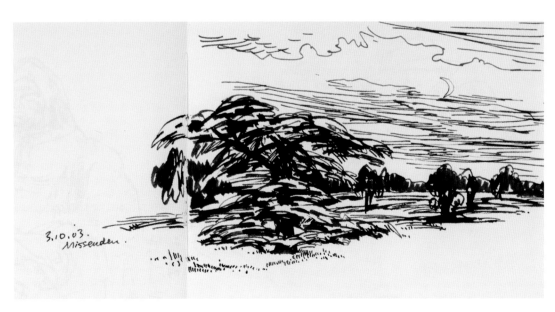

In the evening the light is quiet and open, and when I made this sketch all the lines stretched horizontally, emphasizing this peaceful tendency.

Recording Color

Whenever you have the time available it is important to use either watercolor, oil paints, or some other material to quickly catch the color feature.

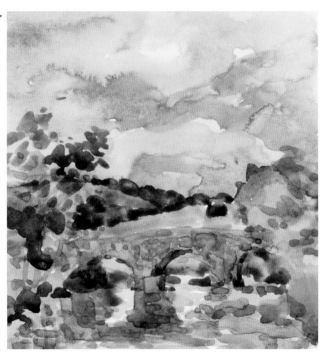

On a cloudy English, day the river and surroundings are bathed in typical calm, cold colors—the green plants and gray stone bridge show very different tones from those when they are under sunshine. The reflections in the water show the same bright, cold grays as the sky.

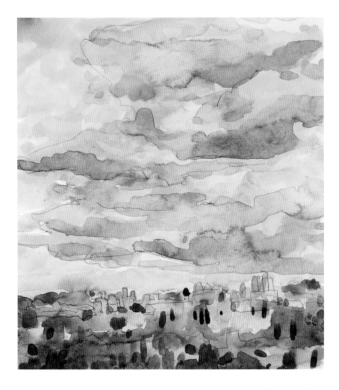

All the roofs, chimneys, and clouds are drenched in beautiful morning light. The purple shades of the houses and clouds further emphasize the bright, warm colors.

In the middle distance I couldn't see the details of the petals of the white flowers. These two blooming white magnolia appear just like a piece of jade carving lifted by the dark green garden background. I just quickly caught that first impression and only then carefully painted a tiny bit of detail on the petal.

The people in this seaside town like to paint their houses in bright, pale colors. Simply including these colors as pale washes on the sketch immediately shows the features of this area.

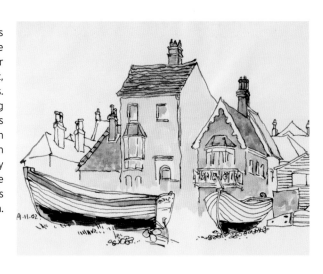

I only had a very little time to capture the dramatically famous red landscape around the ancient city of Petra. I quickly mixed some color as close as possible and painted a small area as a reminder.

Catch the Things that Most Catch your Attention, "Puncture your Heart"

In life there are many situations in which we don't have much time, so it is important to sketch the things that most catch your eye.

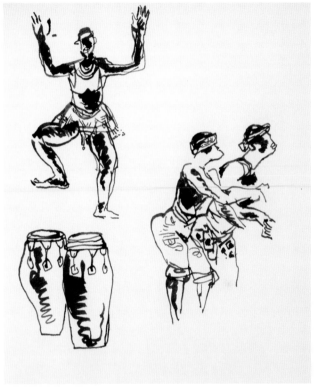

I was very fortunate to be standing alone in Tutankhamen's tomb for about ten minutes, but I knew the guard would soon be shutting the doors. In that extremely quiet tomb I was amazed by the beautiful mural. One of the figures was the most exquisite painting I have ever seen in Egyptian art so I used those few minutes to draw that girl as loyally as I could.

The strong melody, the twisting bodies of the dancers, and their quick movement made the whole scene jump around. The pen in my hand did the same thing—what in traditional Chinese painting is called "the dancing of the brush and the singing of the paint." When drawing, it is important to first catch the moving features—the position of the chin, the bottom, and the knees—and then give the figures a little bit more detail and add other objects to the picture.

Be receptive to the smaller human aspects of our world. This fisherman was alone on the beach on a bitterly cold and wet winter's day. I wanted to include the sea in a big way to emphasize his faintly ridiculous situation.

Don't be Fussy About your Materials

Whenever you see something very interesting but are not prepared, you can draw on whatever kind of paper is available, such as a newspaper, an instruction book, or manual.

Richard was a very respectable old man who worked in the same organization as I did. He enjoyed chatting with people about his experiences. On this day I could only find an envelope in my pocket but because we were both relaxed I was able to catch his character exactly.

I was in church for a child's christening ceremony and noticed the beautiful light shining directly onto the priest, but at that moment the only paper I could draw on the service sheet. The microphone in his hand shows the scene is contemporary.

I was jogging around the lake in the local park when everything disappeared into the mist, leaving on view just this bird sitting on a buoy. I found a piece of sugar paper a similar color to the mist and painted what I saw to catch the atmosphere. In the traditional Chinese way, this let me make half the effort but achieve double the result.

Use Written Words as Additional Record

In many occasions we see a lot of things but do not have enough time to draw them. Instead, we can simply write the necessary information to help us remember it. Also, I often write what I was thinking or imagining in the moment of sketching, just like a diary.

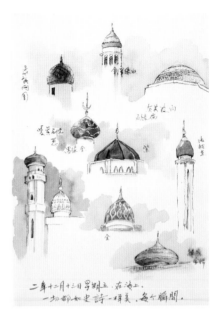

In the Middle East I saw many beautiful minarets of differing shapes, colors, materials, and designs. It was impossible to sketch all the detail, but in a moment it was important to capture the general shape and major design features, and use the words to write down the colors. Back in my room I then put in the color while my memory was clear.

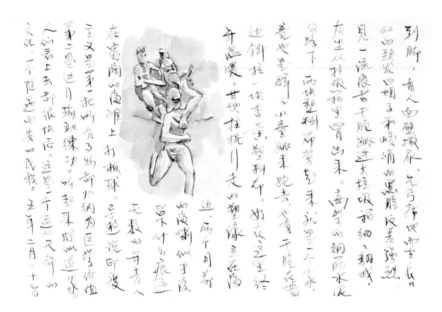

I faced a huge piece of cliff carved with hundreds of figures. The only way to record it was to draw a small, very interesting part with the correct shapes and colors. I quickly wrote my feelings and the story from the guide in words.

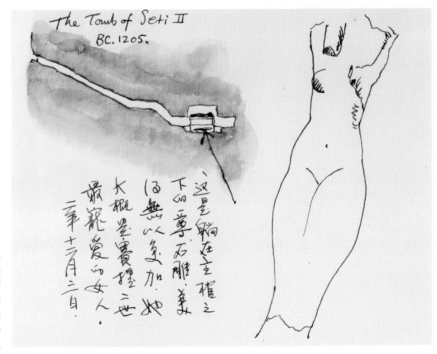

The huge stone coffin in this pharaoh's tomb hid a very beautiful stone carving of a female figure. It caused a lot of uncertainty about its origins, so I recorded all of this by sketching the shape, drawing the journey to the tomb, and writing my thoughts.

Index

Acknowledgments

"Go to work with a will and make speed with your brush.
Select only what you have perceived,
for just as a bird of prey swoops when he has seen the hare,
so your eye must fasten on its object.
Hesitate for an instant and all will be lost."

Wei Bo Yang (2nd century C.E.)

As I do, when you are sketching keep this thought uppermost in your mind to help you succeed.

Over the years many people have helped me with my sketching. I would like to thank Victoria Kennedy and Swan Hellenic Cruises for allowing me to see parts of the world that would otherwise have remained unknown to me while teaching on their voyages.

I would like to thank Cindy Richards and all at Cico Books as well as Georgina Harris and I would like in particular to give my special thanks to Robin Gurdon for his ceaseless patience in working out the English text, without whom this book would not have been possible. Finally, and most importantly, I would like to thank my wife, Caroline, and daughter, Tao Tao, for their neverending love and encouragement.